DOING LIFE

Reflections of Men and Women Serving Life Sentences

DOING LIFE

Reflections of Men and Women Serving Life Sentences

portraits and interviews
by HOWARD ZEHR

Good Books
Intercourse, PA 17534

ACKNOWLEDGMENTS

A project such as this involves the collaboration of many. A very special thanks to the lifers' organizations at Graterford, Muncy, Rockview, and Huntingdon prisons; lifers Tyrone Werts, Bruce Bainbridge, and Marie Scott have played particularly important roles. Without the cooperation of these inmate organizations, the project would have been impossible. Thanks also to the various members of the Pennsylvania Department of Corrections who allowed and helped facilitate the process. Thank you especially to former Pennsylvania Commissioner of Corrections Joseph Lehman (now Maine Commissioner of Corrections) for his approval and support. Well into the project a grant from the Pennsylvania Council on the Arts allowed me to teach photography to lifers during a short sabbatical. A few of the interview and portrait sessions were conducted during this time. Tyrone Werts' words are reprinted with permission from *The Other Side,* 300 W. Apsley, Philadelphia, PA 19144 (215/849-2178). In the process of creating a traveling exhibit of some of this material, designer Judith Rempel Smucker contributed to my vision.

Much of this project was conducted under the auspices of Mennonite Central Committee (MCC). MCC is a nonprofit relief, development, and service agency representing Mennonites and Brethren in Christ in Canada and the United States. MCC staff, volunteers, and partners work in more than 50 countries in education, agriculture, health, conflict resolution, community development, and emergency relief. I serve as director of the MCC U.S. Office on Crime and Justice and consider it an unusual privilege to have had organizational support for this project.

Design by Dawn J. Ranck

DOING LIFE

Library of Congress Cataloging-in-Publication Data
Zehr, Howard.
 Doing Life : reflections of men and women serving life sentences / portraits and interviews by Howard Zehr.
 p. cm.
 ISBN 1-56148-203-X
 1. Life imprisonment—Pennsylvania. 2. Prisoners—Pennsylvania—Interviews. 3. Women prisoners—Pennsylvania—Interviews.
I. Title
HV8711.Z44 1996
365'.6'09748—dc20
 96-8771
 CIP

TABLE OF CONTENTS

About The Photographs and Interviews 3

The Lifers—Portraits and Interviews 7

What Does All This Mean? 118

Index of Lifers 123

About the Photographer/Writer 124

ABOUT THE PHOTOGRAPHS AND INTERVIEWS

The men and women in this book are serving life sentences in Pennsylvania prisons. All have been convicted of homicide or of being accomplices in homicide. Many have already served long sentences in prison. Most will die there.

Pennsylvania is one of only a handful of states that mandates life imprisonment without possibility of parole for anyone convicted of first or second degree murder. For a lifer, the only possibility of release is commutation by the governor, an exceedingly rare event. Life sentences in Pennsylvania are *real* life sentences.

I have worked with both victims and offenders, including prisoners, for many years, but prior to this project I had limited experience with lifers. I chose to focus on them here because we know so little about who they really are.

Issues of crime and justice are near the top of America's agenda today. They dominate our news, our political campaigns, even our entertainment. Unfortunately, though, in most of our discussions about these issues we talk about abstractions; we tend to use stereotypes and symbols. Offenders are faceless enemies who embody our worst fears. Victims—if we think about them at all—become planks in our campaigns, pawns in the judicial and political processes.

We tend not to see victims or offenders as real people. We seldom understand crime as it is actually experienced: as a violation of real people by real people. Rarely do we hear the experiences and perspectives of those most involved.

This is certainly true for people who have been involved in murder. They epitomize our worst fears and stereotypes. Yet prison staff, as well as researchers, often consider lifers to be some of the most mature of all prisoners, those least likely to repeat their crimes. Lifers frequently provide significant positive leadership and act as role models within prison. Because they have been implicated in frightening crimes but often have subsequently matured into thoughtful individuals, lifers are a prime sample with which to examine our stereotypes.

Life, for these women and men, is a life sentence. What does it mean, for those experiencing it, to be locked up for life, with little or no possibility of ever returning to society? Furthermore, what reflections do these persons have on life itself? They have probably thought more seriously than most of us because of the lives they took and because of the difficulty of their own present life circumstances.

To begin this project, I obtained permission from the Pennsylvania Department of Corrections. I also met with the inmate board of Lifers, Inc., the lifers' organization at Graterford prison. I outlined my ideas, showed them previous projects I had done, and explained that my purpose was to present them honestly, as individuals. They made helpful

suggestions about how I might proceed and agreed to identify participants and to assist with logistics at their prison.

Eventually I visited a number of prisons. I asked the lifers' organization at each one to select persons for me to interview and photograph. Prison staff sometimes made suggestions as well. I asked only that subjects be able to reflect on their lives and that they represent a variety of ethnic backgrounds, ages, and perspectives. Ultimately I conducted approximately 70 interview/portrait sessions, but I make no claims that this is a representative cross-section of lifers. Those who have been overwhelmed by their circumstances, who have not managed to mature and change for the better, are undoubtedly under-represented here.

What style of photography should I use? At first I considered environmental portraits in the prison setting. Yet I had noticed how often photographers seem fascinated by the bizarre features of prison life. I recognized how the barren, formidable settings of prison trigger our stereotypes about prisoners. If I were photographed among bars and cells, I would probably look like a stereotypical prisoner, too. So I decided on portraits against a muslin background. The plain background, combined with a "looking-at-the-camera" style of portrait, allows the viewer to see the subject as a person rather than a symbol. The sharp images and smooth tones that result from using a larger, medium-format camera contribute to presenting these prisoners as human beings. I asked that the inmates be permitted to wear street clothes rather than uniforms for their pictures, but I made no other suggestions about how they dressed.

Before photographing these men and women, I interviewed them, asking direct questions about what it means to be locked up for life, what images they use to understand their experience, what if anything gives them hope. After one or two questions about where they were from or about their families, I usually asked, "What is it like to be locked up for life?" Often they caught their breaths, said something like, "Whew, you ask hard questions!" and then began to talk.

After each interview, we did the photographs. I made one roll—12 images—for each person, as much as possible letting them pose themselves. I used no tricks to make them look good. Lighted by a single strobe in an umbrella softbox, posed against a plain background, they presented themselves.

I taped the interviews and then had them transcribed verbatim. I edited for clarity and flow, but I tried to retain the subjects' own words, syntax, and structure of expression. I sometimes clarified their grammar or rearranged paragraphs to make their statements more readable on the page, and I selected excerpts from the interviews. I rarely, if ever, "cleaned up" their language, however. As much as possible, these are their own words.

Toward the end of the project, after seeing some of these portraits in a magazine, lifers at Huntingdon prison contacted me with an interesting challenge. What is missing, they said, is the time dimension. What were these people like when they were first incarcerated? How have they changed?

Subsequently, then, I interviewed several inmates at Huntingdon that dealt with this part of their experience. Each of these interviewees, provided a photo from the time of their incarceration. I made a quick Polaroid portrait of them now, and we began our discussion by having them reflect on the people in those two

photos. These interviews have added an important ingredient to this collection.

Let me be clear about my own views. I am opposed to sentences with the ultimate finality of life without possibility of parole. That bias has been strengthened by my experience with lifers. In recent years I have helped to develop and conduct a program that assists prisoners in better understanding and taking responsibility for what they have done. This has included an intensive seminar designed to have them empathize with victims. The majority of participants so far have been lifers. I also used a short sabbatical to teach photography to lifers in several prisons and have worked with lifers in other ways. As a result of such projects, I have learned to know some lifers very well. I am convinced that with careful selection and supervision, many could be safely received into society and make an important contribution to our communities.

As lifer Tyrone Werts says, however, the issue is even more basic: "We must find new ways to respond to crime, new ways which right what has been disturbed and mend the awful damage crime causes in our communities. All of our lives depend on it."

My goal here is not to press a particular position, but to encourage a dialogue that is rooted in real life rather than abstractions.

Approximately 3,000 men and women are currently serving life sentences in Pennsylvania alone. An additional 150, on the average, are being added yearly. Commutation by the governor is a possibility, but only two or three are released this way each year. An average of 10 die every year. So the number of lifers keeps growing. The long-term fiscal and social costs of this expanding and aging prison population are substantial.

As demands for punishment intensify throughout America, additional states are adopting life sentences and other "get-tough" measures. Consequently, justice and corrections expenditures are the fastest growing lines in many state budgets, increasing at the direct expense of social services, health care, and education. Life imprisonment has important implications for all of us; Pennsylvania's experience may be helpful.

Again, my primary goal is to offer an opportunity to see offenders as individuals with their own fears and dreams, rather than as stereotypes. I have tried to do that without imposing my own images and ideas in the process of photography, interviewing, and editing. As much as possible, this collection of portraits and words are the lifers' own reflections. They contain important clues—to the meaning of life sentences, and to the meaning of life.

HOWARD ZEHR

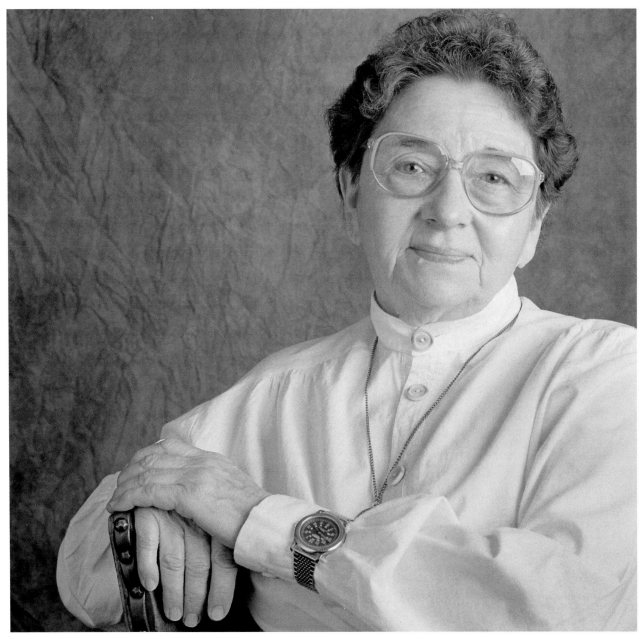

LOIS JUNE FARQUHARSON

"I was in my 40s when I came in. I'm 67 now. I was a practicing psychiatrist and I'd like to get out of prison and contribute. But if I can't, I hope that I'll do as well here as I can in any community: contribute and not make life intolerable for myself or others."

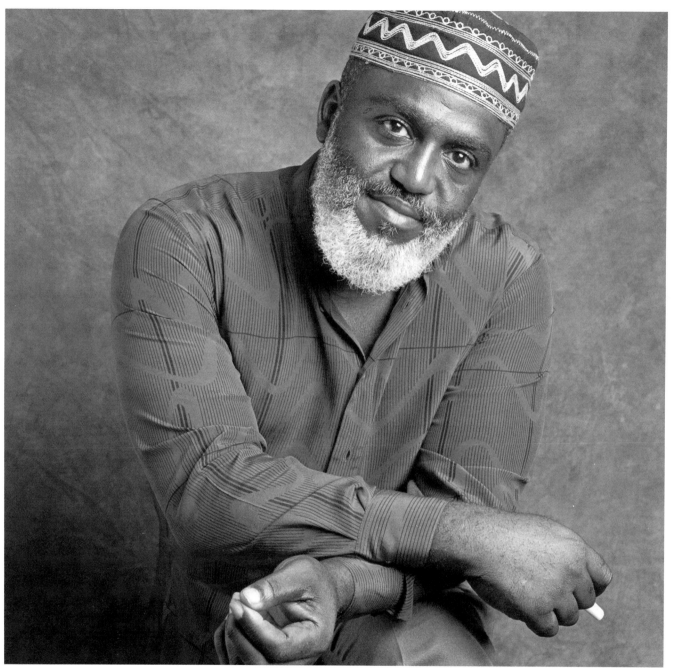

AARON FOX

"If I have one wish, it is that I would be forgiven my sins."

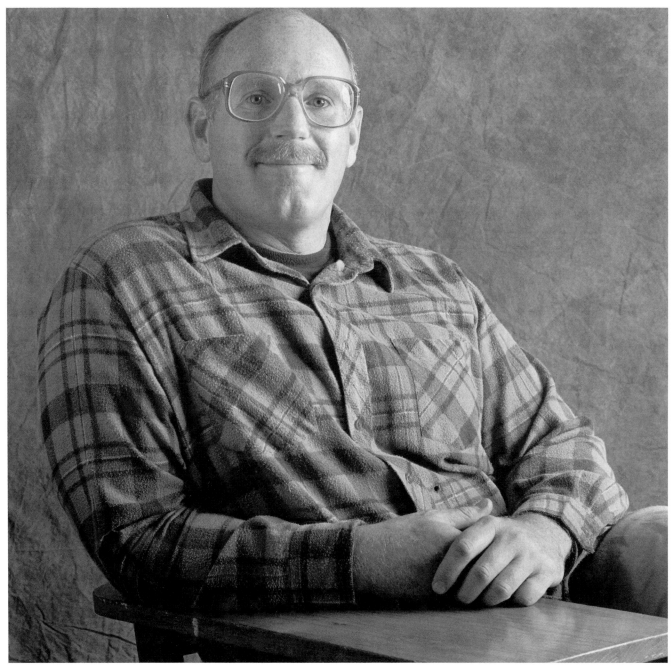

LARRY HOLZ

"I've gotten somewhat wiser. More patient. A lot smarter. A lot friendlier. A bit heavier. Lost a lot of my hair. But my greatest fear is dying in here."

I've been incarcerated 24 years. When I came here, I was a ninth-grade dropout. I was young, fast-moving, thought I knew everything. Then I came across some older lifers. There were some who had served more time than I'd been alive. We started talking. They said, "Here's a little something for you to read." I said, "Okay," and came back the next day to give the book back. They said, "Did you read it?" I said, "Wait a minute—let me read it again." I saw they were serious.

The book was Viktor Frankl's *Man's Search for Meaning*. It dealt with an individual's experience in a concentration camp, which is not too unlike the situation that we're in now. He was in the midst of hell, and yet all around him were examples of man's nobility. Man needs to rise above his conditions and experiences. It touched me. I read it, and we started talking about it. And they said, "Here's another book." And another. I began to see that the world was immensely larger than I had every imagined. I hadn't been off the step. The universe was limitless.

Over the years I've acquired a couple of degrees. I have my teaching certificate, a degree in education, and a degree in business administration. I started officially teaching classes in here, and I found that the best way to learn is to teach. When I walk away from a classroom and I see my students' eyes have brightened up and the lights are going on in their heads, it's a good feeling. But it's an even better feeling when I walk away from the classroom having learned something myself.

I try to teach my students the relationship of one thing to another. Everything touches something else. And my teaching has affected *my* life —my relationships with my family, the people I associate with, my ideas.

Life to us has two meanings. Life is life—the generic term. Being alive, waking up every day. Life is also a sentence to serve. In Pennsylvania, life is to be served until you die.

That life term—you can't get away from it. If I succumb to the pain of it, it would indeed be dangerous; it could do things to the mind, to the spirit. But a life sentence can and should be served with your mind open, aware that life is all around you. That life is being influenced by you, and life is influencing you. We happen to be isolated, but that doesn't limit the mind. Since I've been incarcerated, I've traveled the universe. I've met a host of people, but, more importantly, I have met and come to understand myself as a person, a member of the family of life.

IRVIN MOORE

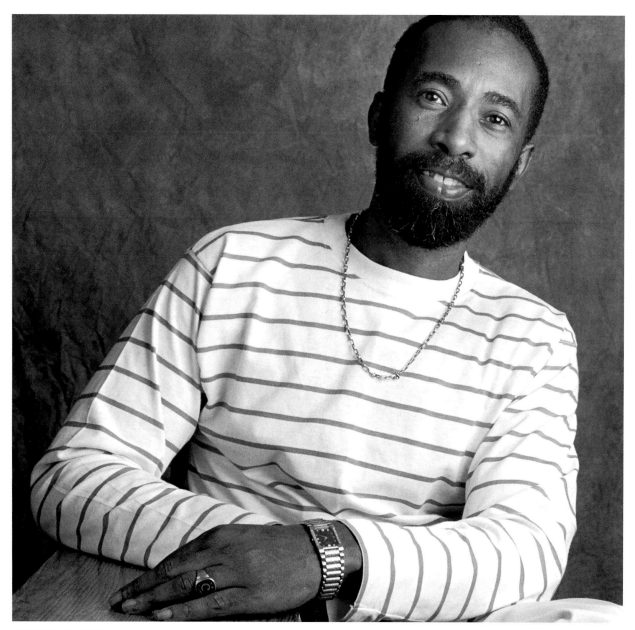

IRVIN MOORE

"A life sentence is like an insect encased in amber. Amber at one point is a fluid. As it is exposed to air, it becomes more viscous. Sometimes insects may get trapped in it. As it hardens, you see the insect's movements become slower. When it solidifies, he's just there. Thank God that I have been able to move enough to keep the liquid around me from solidifying."

I've been in just two years. The first year was a real struggle just trying to adjust. I was overwhelmed. Then I went through a period of extreme withdrawal. Then some of the bitterness and anger started coming out. I said, "I don't like this; I've got to pull myself up and start doing something." And that's where I am now. I still want to be a whole person. I want to be a good person and I've got to go for it.

At this point, I'm just trying to deal with my crime. The hard part is not being able to really talk to anybody about my crime. I want to. I'm lucky right now that they just hired another psychologist and I started seeing her, so hopefully I'll be able to talk through some things with her.

One of the things I have a lot of difficulty with is all the anger that's around me. And I'm finding it in myself now, too. That's scary. I never felt a lot of anger in my life. At times I would feel a lot of hurt. I can see now where the hurt can build up and turn into anger.

I think it's very hard for my friends on the outside. In the beginning, I was very dependent on them and was letting out a lot of pain about what was happening in here. Now I realize the people I have out there truly care and love me, and it hurts them. They're saying, "I love this person but there's nothing I can do." So I have so little to say to them about my life in here. When we meet, I keep it light chitchat. I know there's nothing they can do. A couple of times I've seen tears in their eyes and I just say, "I can't do this to them." Through my crime I hurt enough people. I don't want to hurt people anymore.

One thing I am grateful for is the good life that I had before I came in here. I was able to do a lot of things that I wanted to do. Some of these younger women here just didn't have a chance for anything. Some of them had very hard, very deprived lives.

Ten years from now I hope I'm not here. But I know I will be. I hope 10 years from now I've gotten myself together enough that I'm contributing to others in this institution. I don't want to become a bitter, angry person. That's the last thing I want out of all this.

GAYE MORLEY

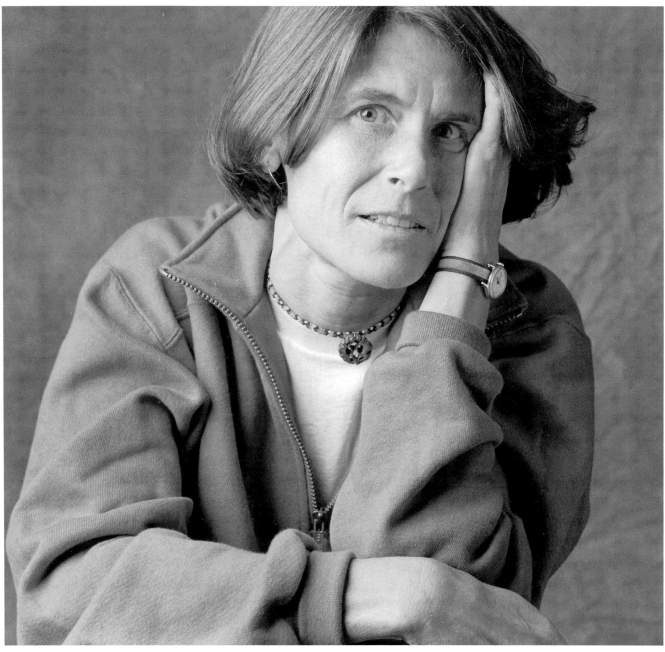

GAYE MORLEY

"A life sentence is a vacuum. Everything is trying to be sucked out of me, leaving me with nothing. I know I have to fight that. I have to create a whole world within myself and hopefully be able to spread that to those around me."

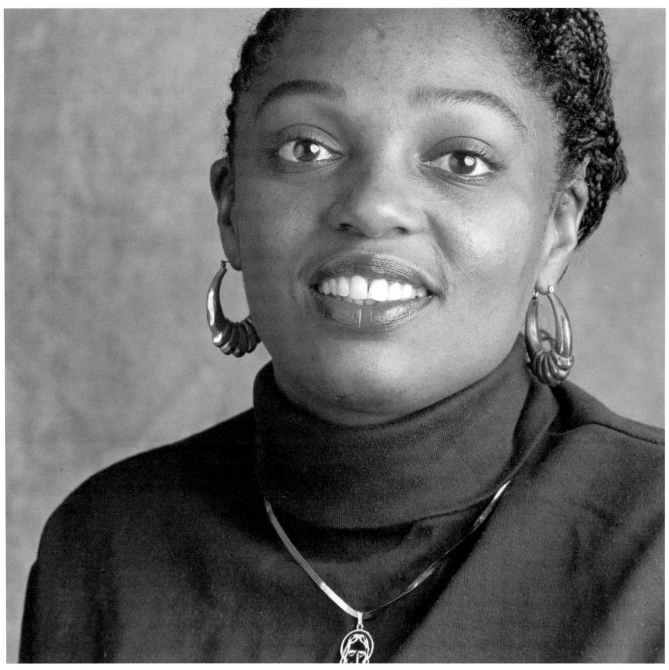

KIMERLY JOYNES

"A life sentence is a black hole of pain and anxiety that you must learn to overcome through spirituality."

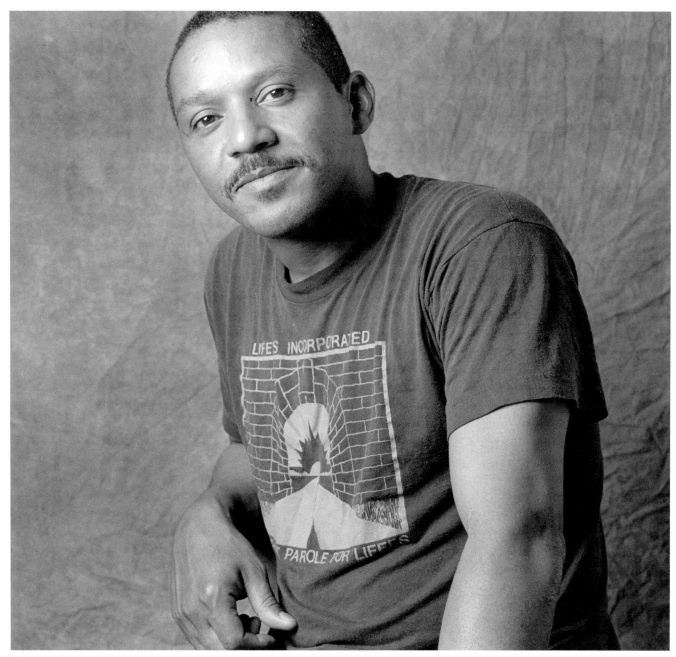

BRUCE NORRIS

" I don't have any problem with doing time for the crime I committed. I own up to that. My only problem is how much time should I do? When is it going to end? I don't mind dying. I just don't want to die in prison."

You're taken out of society, and you're thrust into an artificial community where someone decides what you do all day long and what you can't do. Someone decides when it's time for you to eat. You have no responsibility. And in Pennsylvania it's without the hope of ever returning to society to be a productive and law-abiding citizen.

It's like falling out of an airplane. You've lost all control of your life. You make no decisions anymore. Gravity has taken over something beyond your control, and you just wake up and go to sleep. That's it—nobody to love, nobody to care for. Just iron, concrete.

To deal with it, I lie to myself a lot, tell myself that it's not that bad. People are starving all over the world. People have to live with the violence in their communities. Also, I feel a sense of guilt and maybe I think I deserve to be here. I don't think I deserve to be here for the rest of my life, though. And I try to keep myself as occupied as possible with worthwhile things.

When I pray, I don't pray for release. I pray to get through this day. I pray that I don't make the same mistakes again, that I calm my temper. And that people around me, including myself, learn to get along a little bit better.

The most bizarre thing here is the food. When we get locked up, when they shake the block down, they don't feed you the regular food. They bring a TV dinner. On the street, the TV dinner was the last resort. Here I look forward to it!

JULIUS SCHULMAN

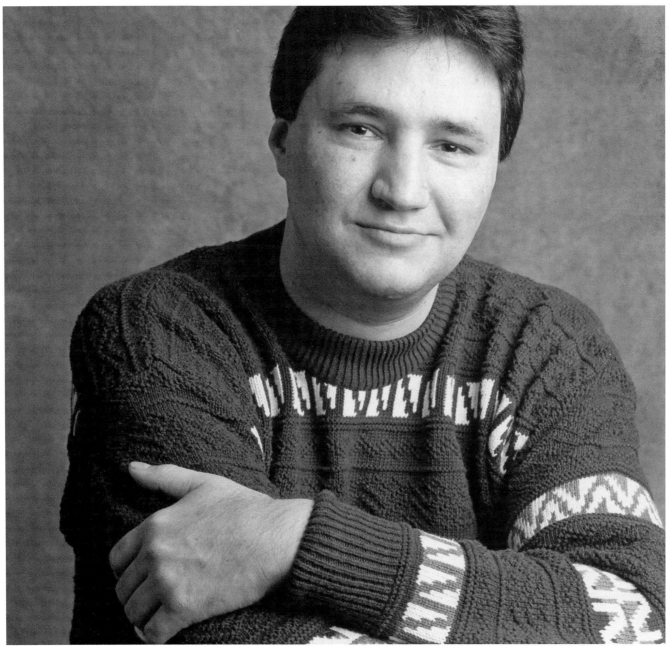

JULIUS SCHULMAN

"One of the best things about going to sleep when I first came to jail was that I used to dream about outside. What scares me is that all I dream about now are penitentiary things. It's like that other chapter is closed."

This is my 21st year. I am constantly thinking in terms of how much life I have left. A life sentence is an endurance test. You're enduring in a vacuum.

What makes it livable is meaningful activity. I've been very active in pursuing my own growth and development. Education was important for me, and I was fortunate to get involved in a trade that I enjoy. I'm a dental technician now. But the most important aspect of my education was to get a business degree.

Another very important thing was my connection to people who befriended me from the outside. Friendships, my family—those contacts were just very meaningful for me.

But the main thing that has made it bearable is my religious life. I'm a Muslim, and I've been quite active in the religion since I've been in prison. When I came in, I didn't have direction for my life. I got in touch with the Creator. I asked for some guidance. I asked for some forgiveness. I asked that I be allowed to live a meaningful life. It was a blessing that I could pursue the things that I have.

When I was younger, with a different mind, I attached my accomplishments to material things like property and clothing. Now that stuff doesn't matter that much anymore. I have taken a lot of focus off myself and placed it on other causes and people. I realize that my life is just one life, that I live in a world and I want to make a difference.

If a genie gave me one wish, I would ask that genie to deliver a prayer to God to bless the lawmakers to grant the parole bill. That bill simply states that persons who have demonstrated sincere repentance and who have worked toward bettering themselves could be released and be successful citizens. This bill would put a mechanism in place so that men and women could be judged on a case-by-case basis. A lot of lifers are ready to give something back to society. That bill would do much to raise the hope level, the desire for betterment, reaching for the future with some hope.

I was taught that in this country of mine, a person is redeemable. That is taught in this country and in religion. You deserve another chance; you get good for good. I have tried to pursue the good. My greatest fear is that I will have to go down knowing that I had been told a lie, that I had been expecting payment for work done. And there was no payment.

JAMES TAYLOR

James Taylor has received public recognition for the inmate self-help program, People Against Recidivism (PAR), which he founded.

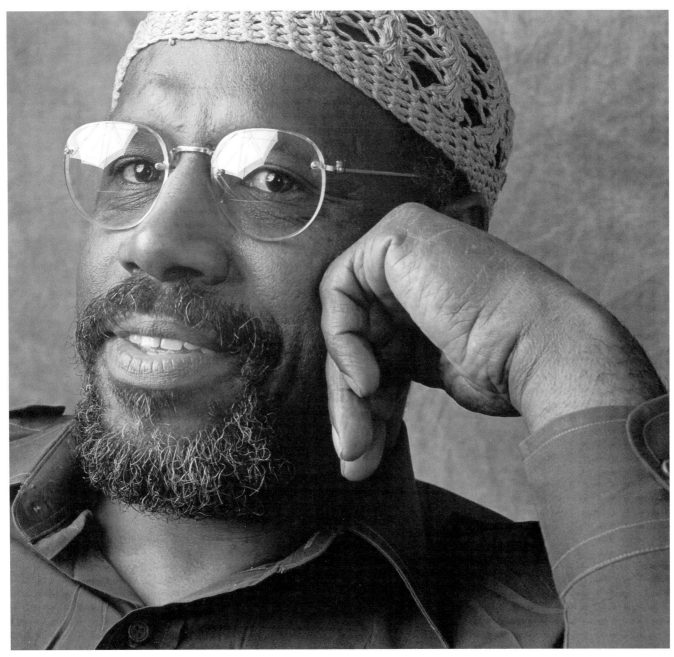

JAMES TAYLOR

"I find myself wanting to tap all the potential that I have to do something with my life. Getting in touch with my spiritual side and constantly pursuing that through practice has really helped me."

People think that this is the belly of the beast. But you'd be surprised. There are some positive individuals in here, some really empowering individuals, who are not criminals. By an accident, a freak of nature, they ended up here. And there are some smart individuals, caring individuals who could be good role models and leaders in society. They are leaders of organizations in here. Most of them are lifers.

These are guys that take time to reach back and pull somebody in and say, "Look, you can do better." At first you're like, "You're jiving me." But seriously and relentlessly they keep on you. Finally you see there must be something to this. Then when you associate yourself with them, you see that you'd rather be with this crew. There are a lot of them in here.

At first when I came in, I was lost. It was such a big place that I didn't know what to do. They saw me, the quiet guy, and said, "We ought to talk to him and get him involved." They approached me and that's how it started. Now I've got to remember what they did for me and pass on the dollar.

You have to believe that if nothing happens the way you want it to, it's not because of any wrongdoing on your part. You have to be strong enough to continue trying to make a change. Hope is something that you can't get from somebody else. You can't read about it and pick it up. It's got to come from within.

It's not easy, though, because I'm not superman. I'm tired of this. I want to go home. The reality is that you can't. So I continue. Besides, there are people like Tyrone, president of the lifers' organization. I've seen him go out and get an award. I've seen him in street clothes. Those kind of things do give you hope, not only for him but for me.

A couple of months ago a guy was stabbed in the corridor. He was stabbed in the jugular vein. I have a homicide [conviction], but I've never seen that. I guess it shows that people commit some acts in a blind rage, and we don't know what we've done. Standing at the window and watching him get it in the neck, and him spinning around with blood gushing out until he fell on the floor—I will never forget that look. It made me realize what it was that I did. I'd seen somebody else do it, and it shocked me. I still see the kid's face. I still see the blood coming out. It made a difference to me. It said to me, "This is what you did," and I don't remember.

It happened in front of our office where I work, and the accountant wouldn't open the door to save the kid. Paranoia set in and he didn't know what to do. It goes to show that some people who are in positions of authority, with keys to the door, panic themselves.

Not many funny things happen in this place. Not many funny things happen. You have to make it yourself—you have to be able to make fun yourself.

RICARDO MERCADO

RICARDO MERCADO

"I've learned that what you do always affects somebody, even yourself. I've learned integrity and how I had none. It hurts thinking about what I did. You often just want to put it aside. But in order to go forward you got to remember where you came from.

"Life is like being in a large room where you can't feel the walls. It is dark, pitch black. You don't see the light. Everyone talks about it but you don't see it."

From what I hear from people who come in, they talk about me on the street as if I'm dead. A life sentence, in essence, is death. It's one step away from it.

In the younger picture here, I was a cocky individual, didn't care anything about anybody but myself—a self-centered person, full of hate, resentments, bitterness, anger. I thought everybody owed me something, and I was planning on taking it from everybody. I didn't want to work for

young **HARRY TWIGGS**

it; I'd rather have taken it from them.

In the other picture, I'm 45 years old, and I've been here 23 years. I'm a man who has come to grips with himself and the world around him. I understand that I am only here for awhile, and that I should try to make the world a better place than it was when I came here. I feel remorse for the things I've done in my life, and I want to try to make it up to the people that I've done it to and to society as a whole.

I'm still a person that is driven, an assertive person. I still believe in causes, but now my causes are positive as opposed to being negative. Before, at the age of 22, I had a cause. I wanted to get high. I was a drug addict. So my cause was to get drugs by any way that I could, to rob, steal, whatever I had to do to get high. At 45, I get high off bringing kids into this institution and telling them not to do the things that I did when I was their age. I get high off accomplishments. I still have that same drive and that same determination, only it is for something positive.

I changed around age 38. I just got tired. I looked at my life, and I saw that what had got me a life sentence was drugs. I saw the lifestyle I was living had got me a life sentence.

I was in the hole when this happened. I stayed in the hole a lot during those early years because I continued to use drugs up until I was the age of 38. I was a jailhouse drug addict. Then I started looking back on my life and saw that drugs and my lifestyle had got me here, and that's when I said I want to make a change. But it didn't happen overnight. It was a process to get me to where I am today.

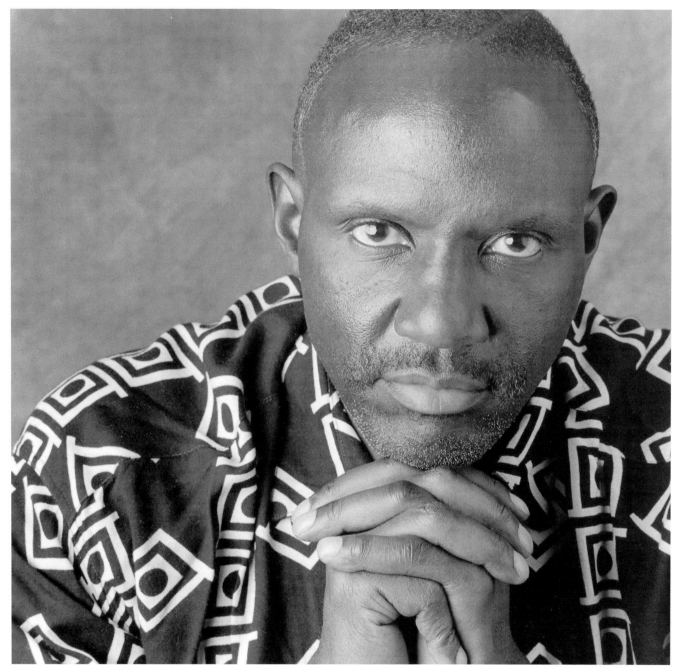

HARRY TWIGGS

I am no longer a criminal. I don't have any criminal thoughts. I don't try to get over on people anymore or try to steal or be slick. All the dope addict mentality that I had inside of me has been channeled in a different direction. My anger at society has been channeled in a more positive direction. Now I want to help kids stay out of prisons.

What made me change was a combination of pain, suffering, being in prison so long. Then I became a Christian, but that was only after three or four years. It was mostly the pain and the looking to see that I'm never getting out of here. I mean, you got positive thoughts for maybe five days out of the week, right? And then two of those days you would be saying, "I might die in here." That stark reality hits you sometimes. That made me want to change.

I look at it like this: the pains that it took for my mother to bring me into this world—all I brought her was pain all my life. I started reflecting on the pain that I caused her, on my never being able to do anything for her but cause tears and pains. Having her see her son sentenced to life in prison, her being a Christian woman, knowing that her son had killed somebody . . . all these things, it was totally against everything that she had ever planned for me in my life. I want to see her justified for the pains that she went through to bring me on this earth by doing something for somebody.

I have been rebelling all my life. So to say I was rehabilitated, that would be a misstatement. I'd rather say that I was reformed, or transformed, from what I was.

The system does get credit. They offered me a lot of programs. When I first started changing at 38 and 39 and 40, I knew I wanted to be different. So the prison offered me programs—thinking programs, decision-making programs, positive thinking programs. They taught me how to think, how to make decisions, how to be a rational individual, how to have goals and aspirations, that I had to change the unfocused energy. These programs gave me the tools to know how to put this thing into perspective, how to put the changes and goals that I had into some type of structured design. So yes, this prison had a lot to do with me changing, and it had a lot to do with me restructuring my life. And I'm grateful for that. Because had I continued to be on the outside, I probably would be dead by now at the rate I was traveling.

A lot of people have been role models to me. Black leaders Jesse Jackson, Martin Luther King, Malcolm X, Marcus Garvey, Nat Turner, Frederick Douglass. So many have been inspirational. Then there have been other Americans that have been inspired me: Mario Cuomo is one. Napoleon Hill, W. Clement Stone, and Norman Vincent Peale have also inspired me. I know that I have the power within me to be what I want to be and that I can transform myself and that I don't have to stay the way I was.

I didn't know anything of this in that first picture. I thought I knew everything, and I didn't know nothing!

I've always been taught growing up that I should expect the worst and hope for the best. And I've learned that when you expect something, it usually comes. I've always expected to be harassed. I've always expected to be punished.

When I look back, I see that I brought a lot of stuff on myself. Now, today, I am in the frame of mind through positive thinking that I expect the best. That's different from what I thought growing up.

It is very hard to keep that up in here, but I have to do it because so many guys in here have given up. My thing is that I'm not staying in here because I know I have something to contribute to society. I know I can go out into my community and make a difference. I've been through just about everything a man can go through in the seasons of his life, and I think I bring with me a wealth of experience. I can talk to a young kid that looks like me, acts like me, has the same mindset that I had when I was 17. I can tell him that where he is headed is to hell.

Where I come from, a man is judged by his *lack* of respect. That makes you a man. In school, the guy that doesn't study, that doesn't get good grades, is considered more hip than the guy who goes to school and studies. If you drop out of school and get a job, you get points for that. You join a gang; you get points for that. You hurt somebody and everybody sees you hurt them; you get a point for that. You kill somebody; you really get a point for that. I mean you'd be at the top of the heap because you took another person's life. When you go to a juvenile jail and you come out, everybody is patting you on your back. "Yeah, yeah, you went to prison."

I can recall the first time I got arrested, how proud I felt sitting in the police car. I was sitting in the police car riding through the community, and I felt like I had really arrived! That was a major point in my life. Then I got sentenced and went to a juvenile facility. That is where I really learned not to respect anyone. When I came out of that place, I couldn't even call my father "dad" anymore! I just referred to him as "hey"; something like that. All my sensibilities, any kind of compassion and love that my parents had put inside of me, all that was taken out of me up at that place because it was a hard place. It was a hell of a system.

I came out of there and became a role model. I spread this philosophy throughout my gang: be hard, kill, hurt, don't have no compassion for nobody. So I'm guilty of being one who was a propagator of that mindset. These young guys that you see today just coming in here, I am their father. I am the one who taught them that stuff, me and the ones who came before them, 45-year-old guys like me. The stuff that they are doing now, I did that stuff already. I didn't do it on the scale they are doing it today, but I started them acting like that.

I feel bad about it. That's why I talk to them now whenever I see them headed that way. I'm trying to make up for it because I know it is my fault.

The code was this: you couldn't be a coward, you couldn't be a "snitch," and you couldn't be a homosexual. Those three things were taboo. Now if you were a murderer, a burglar, a rapist, if you hurt old ladies or snatched their pocketbooks, that wasn't looked down on.

I didn't care about other people. I didn't have no spirit whatsoever. My whole thing was me. I wanted to get high. I wanted money. I, I, I. I victimized everybody. I victimized my people, my

mother. I victimized the man who brought me up, who really was like a surrogate father to me, my grandfather. I robbed him, took his pension money. I didn't have any remorse. He accused me of it, my family members accused me of it, and I denied it. I just confessed about four years ago to my aunt. After I started to change, I wrote her a letter asking her and everybody that I had hurt to forgive me for that. So I didn't have no regard for nobody.

Ask me how I got like that, man, I can't even explain it. Really I think it comes from poverty. We had seven siblings in my family. My father had a job, but it wasn't really paying enough to take care of all those children, so we lived in the ghetto in extreme poverty. When you grow up like this, the struggle takes all. You fight to eat; you fight to survive. You don't have the proper clothes to wear to school. I went to school with holes in my socks and shoes, and on the way to school, I stepped in dog feces. I am sitting up in school and I don't even know it, but the dog feces has gotten on my sock, so this is smelling up the whole place. I mean, I'm talking abject poverty. It takes from you the spirit. You have to crawl and fight, and it kills that spirit in you that makes you care about other people.

There is scrapping and grabbing in the house for food. If you come in late, there's nothing for you to eat, and you might have to go to bed hungry. This kills the spirit in you. And so when you go out in the world, because nobody cared for you, because you fought in your own house, you don't care for nobody out there. You just scrap and scrape. What you did in your house, you do right out there in your community. You go break in the neighbor's house next door, steal all her stuff, and don't care nothing about that.

Self-respect is part of it. Because you don't have anything, you try to distinguish yourself from other people. I started robbing people by sticking up with a gun. I might have some new clothes on then, and I was automatically put on a pedestal. I was given status because I had robbed somebody. That's where it starts.

You want to be somebody, so you don't try to be somebody from within. You try to put on clothes to be somebody. A hat might make you a somebody; some sneakers might make you somebody.

All of this outward stuff, but your inner person lies dormant. You dress up the outer part of you and that makes you somebody. A brand-name pair of slacks, a brand-name pair of sneakers, a brand-name hat. You are somebody because of what you bought, not because of who you are inside.

I had real low self-esteem because of my complexion being dark. I thought I was ugly, and this made me mad and angry. I had pain in me, and when a person feels pain inside, they want to make somebody else hurt. You don't give a damn—hey, I'm hurting! I'm hurting like hell! I can't get no girls. I don't try to approach them because I think I'm ugly. I think I'm worthless and no good.

Because I feel like that, I'm walking around with an arrogant attitude. I feel pain, so I'm going to make you feel some pain, too. I don't have no money. I don't have no self-esteem. I don't have nothing, so therefore I'm going to get you, cause

you got something. I don't like you or America because you got something. So therefore, I am going to hurt you. That's what happens, man.

I look at this picture and I see all my youth wasted. Twenty-three years wasted in here. Years I can never get back. Productive years. I feel sorry and remorse for what happened to this young man. If I, this 45-year-old man, could get out of this picture and go talk to him, this 23-year-old guy, man, I would tell him to get an education. I would tell him to stop and get that anger and hate out of him. I would really talk. I have a lot to say to him. But he's gone, and in his place is this 45-year-old man. I can't—this is over—so I can't be lamenting about the past and the fact that he's gone. All I can do now is try to talk to other 23-year-old guys that I see headed in that direction—try to talk to them, because I can't talk to myself anymore.

A life has been taken, a black man the same age as me. He pulled the gun on me, we struggled for the gun, and I got the gun and shot him in his head. He's dead, and now I am being killed slowly right in this prison here, and it doesn't have to be that way. I can make a contribution out there. I am sorry for him dying and sorry for my hand being the one to take his life, but I can make a contribution out there. I took a life, but I can save lives now if I'm given a chance. I can go out on the outside, and I can talk to kids in my community because I know what's got them. I am not saying that I can save them all, but there are some that are at risk that I can get down in the mud with and save. I can save lives.

I don't want no money, no big car, none of that, because I know that none of that means nothing. When I am dead and they land me in a casket, I want people to say, "Yeah, his life started out bad, but it ended good. He was a bad person in his youth, right, but look at him, what he did before he died. He helped people, he saved those kids, and he started programs out here for children, and he went back into prisons and he taught the gospel." That's what I want my legacy to be.

When I see young men come here, it brings back memories. I can just look at them and tell by how they walk in what they are going to be and how their life is going to be. I tell them, "My past is going to be your future unless you change." Some people choose to learn their lessons hard. That's the way I had to learn mine.

I feel definitely connected to the man in this early picture because he is the one that made me like I am today. His pain and suffering is what makes me be empathetic and sympathetic the way I am today. I bring him with me because I can see out of his eyes. That makes me able to relate to younger guys because he tells me what they are doing. You can't lie to him because I already know. I have been through all of that. You know what I mean?

HARRY TWIGGS

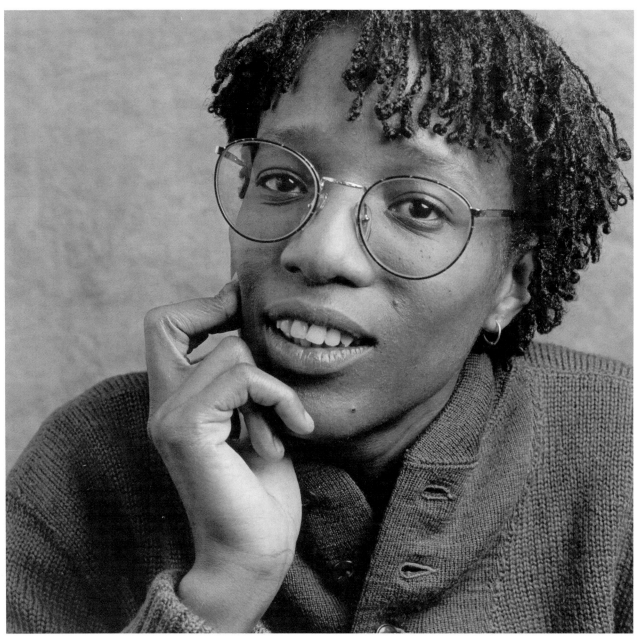

YVONNE CLOUD

"It's like nothing to hold on to. Like being in total darkness and you don't know whether the light is going to shine through. But even though I'm in a bad situation, there are people in worse situations than I am. There's always somebody worse off than you."

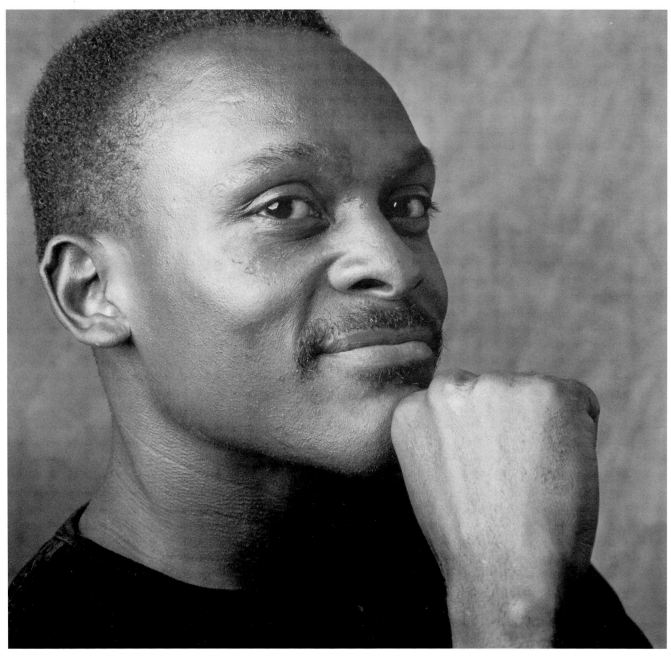

BRIAN WALLACE

"When they say 'life sentence' they take a man's hope, and when you take his hope, what else does he have? All you can do is hope and pray and remain striving in the way of the good."

When I first got the sentence, I was under the impression that it was only like 12 years or so. Then I met some people that had close to 40 years in jail and I was really shocked.

Sometimes I think it's good that I came to jail, though. Don't get me wrong. I don't want to be here for life. But it's made me look at things a totally different way. For example, now that I don't have a lot of things, I notice how important family and friends are.

When I was at the police station the night I did the homicide, I was trying to play tough guy. After sentencing, it still didn't hit me what I'd really done, how terrible a thing I'd done. Then my grandfather passed away and I kind of got a feel for what I had done, taking someone's life like that. I was close to him so I could imagine what the guy's parents and brothers and sisters felt like when he was gone. My loss made me realize the loss his family must feel. I'm just starting to realize a little bit more as time goes on what I really did. And it's something I can't take back.

I think about it all the time. It's been in my head every morning since I got arrested, just waking up and wishing things could be different. Sometimes I go to bed and think, maybe if I go to sleep, I'll wake up February 9, 1990, back when it happened, and we can straighten it out. But I wake up in Rockview.

I try to stay positive. Then something happens and your mood can just flip. It hits you: "I'm never going to get out of jail." The next thing you know, boom! You're back down to the bottom.

When people think about jail, they think of the physical violence. But there's a lot of mental anguish, too.

MARK GRABER

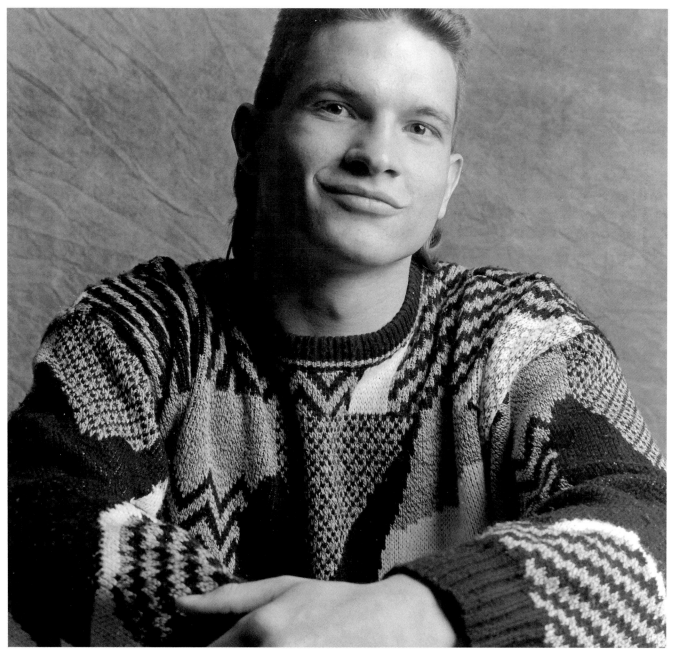

MARK GRABER

"There are times when I call my friends and they say, 'We're going down to the shore this weekend.' I'll be happy for them, but then it hits me—I should be down there with them, but I'm not. I'm stuck here."

I've grown up in prison. It's the only life I really know. I never learned to drive a car, never got to be on my own or go skiing or do the other things kids do at 16 or 17.

Days go into months and months into years. Your family is there in the beginning, but as the years go by, they start fading away. My mom passed away in May, and it was the hardest thing to endure. I just knew she was going to be there, regardless; I could always talk to her about things. I thought doing a life sentence was the worst thing that could happen to me, but losing my mom was the worst. I try to block it out so I don't crack.

I was very immature when I was arrested. It was like whatever happened, happened. Now I'm not taking things for granted. I think about things, like, "If I do this, what's going to come of it?"

You're not in control of your own life here, yet you can be in control of your own destiny. If you wake up and say, "I'm going to make this day of my life sentence miserable," that's how you'll have it. You make it what you make it. And I'm going to fight to get out of here because there are things for me to do out there. I'm going to give back to people what I took from them.

My dream is to leave here in a white limousine with a white Siberian husky sitting in the back seat with me. I want to go down the road thinking about what I'm doing, then go sit on top of a mountain and plan my life. Just sit there and think about what I'm going to do with the rest of my life. That's my dream.

SHERRI ROBINSON

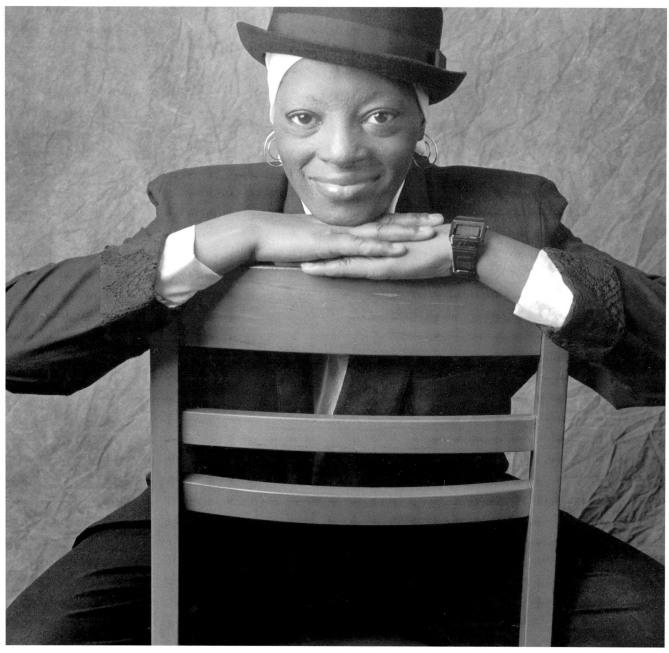

SHERRI ROBINSON

"I was arrested when I was 16. Now there's a 17- or 18-year-old girl that just came in. I felt so bad. I wanted to grab her and hold her and tell her it's going to be alright. But I know it's not going to be alright."

I can't be an asset if I go out the same way I came in. So that keeps me going, keeps my hope alive that I can make a difference.

My first intention when I got here was to seek and destroy. It took an old-timer and also a teacher by the name of Miss Raphole to swing me around. I'll never forget the teacher's words: "You're going nowhere fast, but you can change it all. Can't nobody do it but you." Every day she just drilled home her message. And the old-timer saw something in me I didn't see myself. He gave me respect, so I tried to give it back.

Nothing went wrong in my family's lives until after I got locked up. That's the hardest part that I have. I think about my sister and wish I could help her. Or my brother sleeping in a shelter. I know if I was there I could do something to make a difference.

I've seen men kill themselves, just fall apart to the point where they cut their wrists and bleed to death overnight. Or put a rope around their neck and jump off the tier. You see a lot of grue-some things. That keeps you focused because you go back to your cell and think, "Damn, I don't want to go out like that." Then you try to find out why he did it. You already know 80% of the reason why he did it. But there is the 20% gap there. Did his woman leave him? Did someone in his family die? You want to know those things so you know how to deal with it in case it happens to you.

That's the way I've always been. I don't learn lessons about life through actual trial and error. I learn through other people's trials and errors. When they make a mistake and it costs them, I want to examine and find out why. They do something good and it elevates them, and I want to know that, too. That's one of the things that keeps me focused and keeps my hope alive. Outside of that there is nothing else.

CALVIN MARTIN

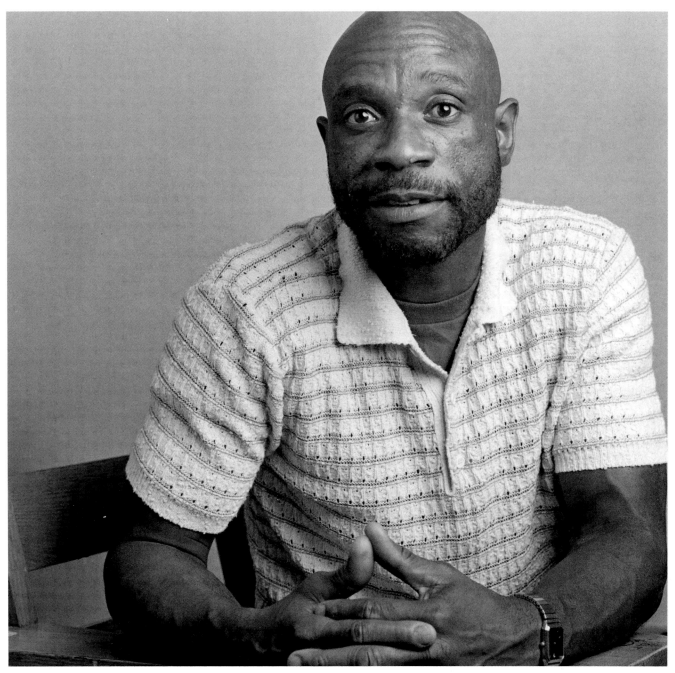

CALVIN MARTIN

"I'm not faring well, but I got my life. I ain't living well, but I'm alive."

When I first came, there were so many guys locked up from my neighborhood. At one time on one cell block there were 21 guys from my neighborhood. I looked at them and saw that they were doing the same thing again and again. I said, "This has got to stop somewhere. I don't want to be like this the rest of my life." And I motivated myself. I said, "This isn't for me."

During the hostage siege over 10 years ago, I was working in the hospital. I volunteered to take medication in to the hostages, guards, and inmates. I knew what could happen, the possibilities of how it could end. For me to be viewed as someone who could be trusted to do something like that showed me that I had progressed.

To be truthful, I needed part of this time to get to know myself. The way I was going, I'm going to admit that I did need a little of this, but now it's like overkill. I know my mistakes. Some learn; some don't. I've learned.

WILLIAM FULTZ

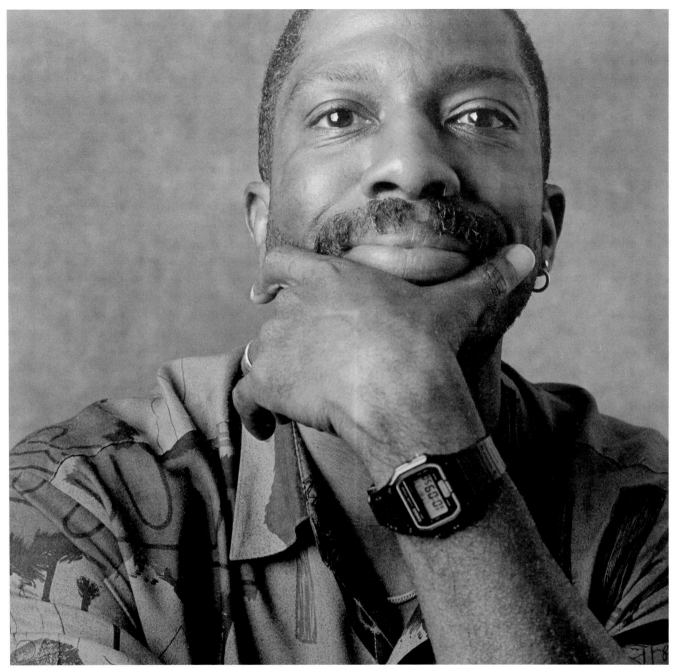

WILLIAM FULTZ

"I"ve learned that if you don't think, somebody else will think for you. And life is very precious."

Every day is depressing. Every day is the same. You're just here to die. But yet as life goes on, you live it and you try to make changes and do things, feel human. We all find our own way to try to be productive.

My art keeps me going. I paint everything. Right now I'm working on a project for the chapel. It's the Last Supper, seven feet by 11 feet.

I was watching a TV program and I saw Bob Ross do a landscape within half an hour. It kind of moved me. So I tried pastels and then went to painting. Now I'm growing. It helps me as therapy. I can think, I can figure things out which I couldn't do before. It's a God-given talent I didn't know I had, and I thank God I found it. I feel like I'm doing something with my life now.

Before, I was a weak person. I became a chronic alcoholic. I didn't care about eating; I drank my food. And I was taking prescription drugs with the drinking. That's how I came to be here.

Alcoholics Anonymous helped me realize that life is pain. When you drink, you're running away from life. Now I have come to realize that I have to stand still and face pain, happiness, everything. It's not that you can run away from it.

JOSEPH MILLER

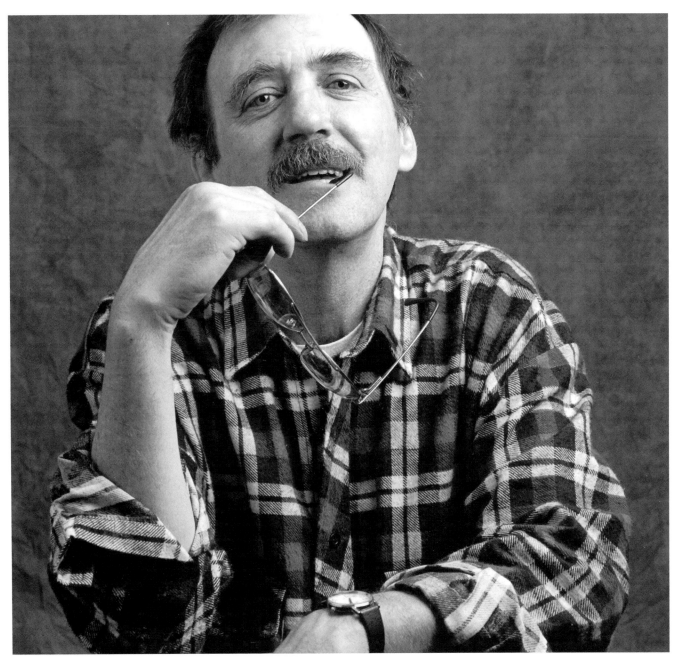

JOSEPH MILLER

"I drank for 25 years. Then I stopped and started feeling the real pain of being here. Now I have come to realize that I have to stand still and face pain, happiness, everything. That's what life is about. Now my art keeps me going."

Prison is the most dehumanizing place on earth. I can't think of anything worse. I took my family to the zoo and I looked at animals. They have it just a little bit better than we do in here, I think, in a lot of ways.

For the first years, I said, "I'll never get out." My wife divorced me, and it was hard for me to get over the fact that I might never see my children again. Now, for the past 15 years, I see a light at the end of the tunnel. I have a little more faith, and I get a lot of strength through prayer.

I never knew how to express it in a pure sense, but I've been pretty much God-fearing all my life. But then I didn't pray as much as I do now, because I didn't know the value of prayer. Now I find myself saying little prayers throughout the day.

I empathize more today. What made that happen was all the doors inside me opened up. I harbored a lot of sensitivities because I had the wrong concept of what manhood was. Before I used to think crying wasn't manly. Now I find out that when you cry, it is a form of growth, full of strength. There's only a few guys in here I can talk to like this. But crying is a form of strength. It's cleansing, and it's good for me. Now when a guy tells me that his mother passed away, I can really feel sorry for him because I've had family pass away.

I keep everybody at arms' distance. It's a mild protection because there was a guy that I used to be real close to. He wasn't doing a life sentence, and me and this guy used to go everywhere. When he left, it broke my heart. He left me behind, and a huge part of me wanted to go with him. I said, "From here on out, I'll just have peo-

ple in here that I get along with, but I don't want to have that tag team thing. Not this guy trailing me all day, eating together." That way it keeps me from hurting a little bit like that.

This has been the fastest 25 years in my life! The years just fly by. It seems like I wake up one day—it's January—and when I wake up another day, it's June, and I look at the next day—it's Christmas! Every morning I get up and, before I wash up and everything, I sit on the bed for five to 15 minutes and I say, "Is this for real? Is this a nightmare? Did I die and come back as somebody else? God, are you listening to me?"

There have been a lot of dark days, believe me, but I haven't really suffered because I think every day I've contributed to uplifting somebody. A lot of times I feel like that I have a white collar on because I have guys that call me Uncle Al. I listen to everybody's case, and I think I get more drained that way than I do working or working out every day. Sometimes I wish nobody would come to me today about anything, but when people look up to you, it's a real good feeling.

I just don't know how to approach God one-on-one about myself. I don't know whether deep down inside I am telling myself I deserve being here because that was a horrendous crime, even though I didn't actually kill anybody myself. That still was a horrendous crime. Maybe I should be here for something like that because the person that died can never be returned to his family. I can just imagine how much hurt and pain they have to go through all their lives. So I'm thinking that maybe I should be here. Then

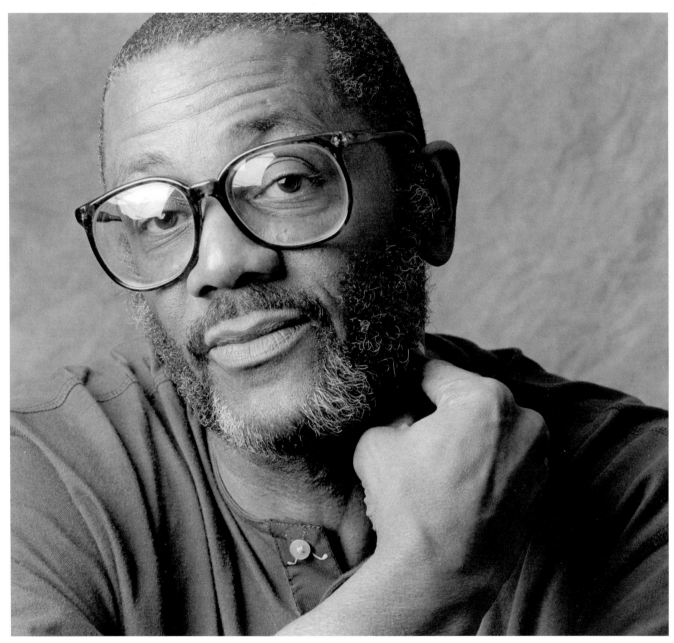

ALVIN JOYNER

"Sometimes when I do things I say, 'I hope some angel records this. I hope the scales balance.' I don't think the scales are balanced for me to be here like this. But I know God knows everything and He's always present, so I just try to be the best I can."

in the same breath I am asking God, "For how long now?" Sometimes I wonder how much more I can take.

Some people say some things are ordained or decreed to be, and I wonder whether it was decreed for me to be here. I met people here that have been very fruitful in my life. For instance, my girlfriend. She's been hanging out with me for 15½ years, a very good person, very steadfast. If I never came to prison, I don't think I would ever have met her. So I am just confused about how deserving I am of anything.

That's the thing that pricks me the most. In that little period when you lie down on your bed searching for sleep, there is always a little moment, that little period, when you think. That's when I usually have all those questions.

I try to ask God to forgive me for why I am here. I petition Him to touch the family of the deceased in some kind of way. I try to seek forgiveness through Him because I know He's the real judge. And I am very remorseful. It's a pretty profound thing to kill somebody or to kill yourself.

ALVIN JOYNER

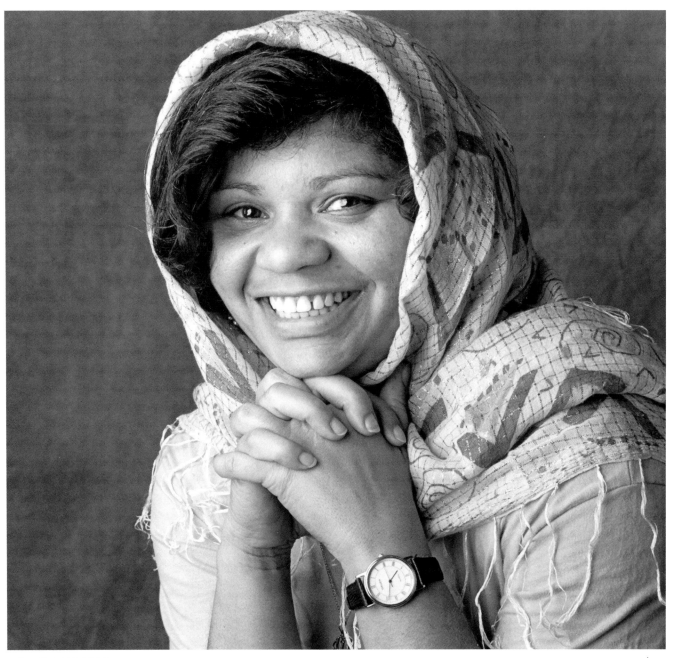

RENEE THOMAS

"A life sentence is like a fire that I can't put out. There's not enough water to put it out, because, no matter how much I try to better myself, it's just not enough."

Three or four years ago there was a story in a local newspaper about a school that needed volunteers to make braille for blind students. Through my wife I submitted a proposal that eventually was approved. I sat down first with a mechanical brailler and learned the braille language. Later I had a computer. I entered textbooks for school kids. My goal is to make something useful out of my life, which for all practical purposes is over.

A life sentence means that, in effect, you're dead. It's just another form of a death sentence. Instead of having the gall to do it in one fell swoop, you die one day at a time.

I've changed. I understand to a certain extent what the Griffin family suffered from the things I did. They got caught up in something that wasn't their making. Now James is dead, the husband. I don't know what his wife is doing, but it affected her. And his mom and dad. There's just no way to address it.

Victims don't exist in the criminal justice system. It's the power of the state. You've offended the *state*. Let's call the victims over here and get their input, then throw them out. The victims aren't supposed to be made whole.

This should be a system where the victim is made whole in a meaningful manner. If it takes me the rest of my life to pay for it, then that's the way I should pay for it. But if I sit in a corner of a cell and you pay for me to be in prison, I'm not paying for nothing.

THOMAS MARTIN

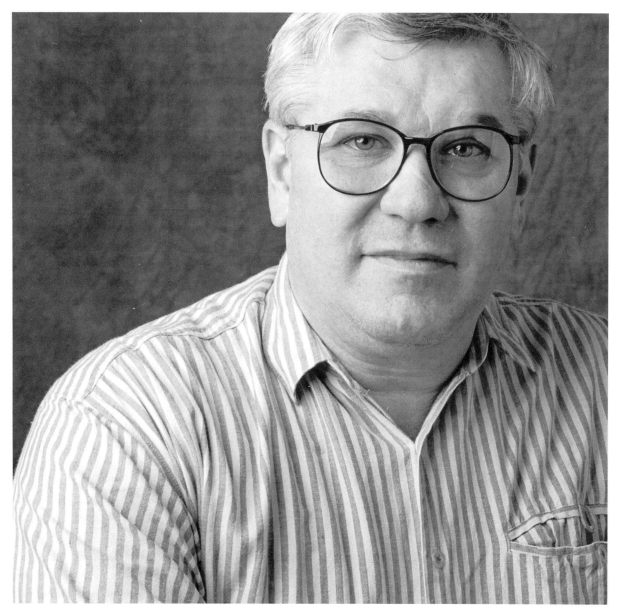

THOMAS MARTIN

"There is no way to undo what I did. But to some extent I understand the suffering my actions caused. The most painful thing about a life sentence is the harm that I caused.

"A thinking man wants each day to matter. Maybe that's one of the dilemmas. Too many of us think in here. So you face each day, not by saying, 'How do I just struggle through?' but 'What can I do to make something of this day?'"

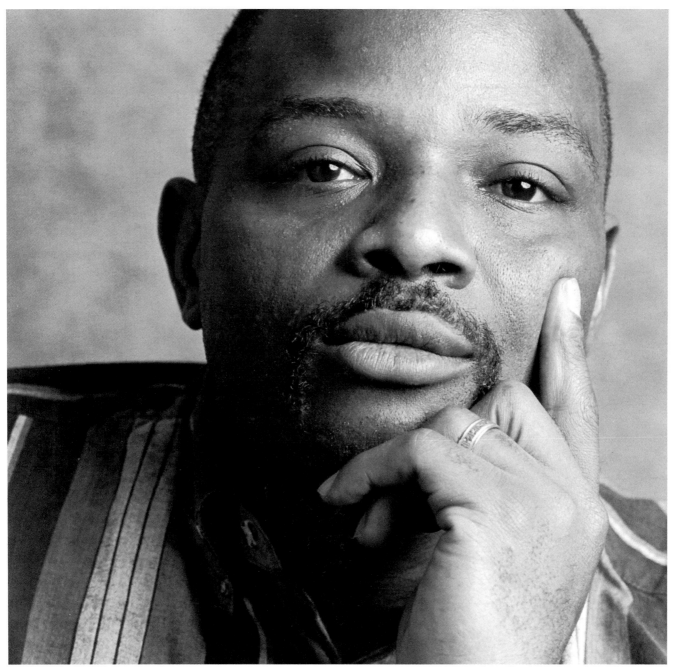

JERRY MIMS

"In the midst of the despair, you try to maintain as much balance as you can.
You have to align yourself with people who are headed somewhere in life."

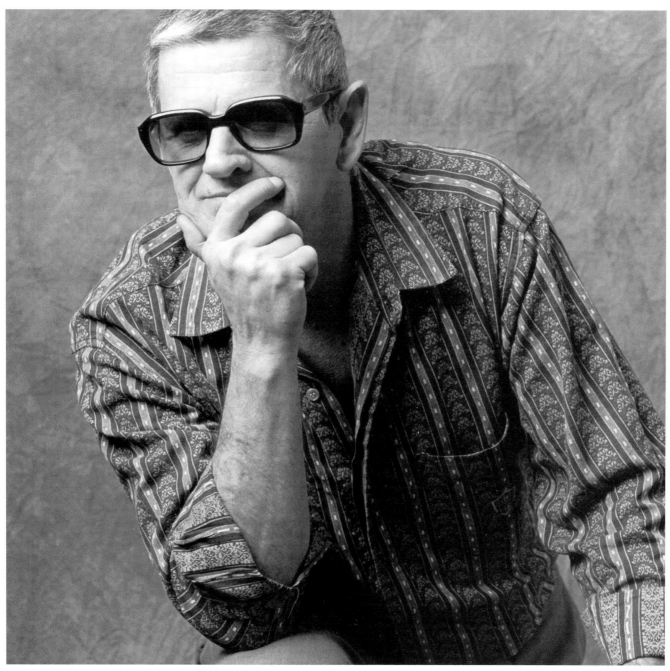

GROVER SANGER

"It's not having a date. The time I can handle. It's not having numbers at the end of it."

When I came here, I was like in a cocoon. Since that time, I've evolved. I'm a butterfly now, and I'm ready to fly away. I think I have a lot to offer the world, and I've made a commitment to myself that if I get out, I'm going to do just that.

I didn't always have as clear a sense of who I am as I do now. When I was out, I was hung up on pleasing everyone, and I tried to live out their expectations. I lived for everyone except Cyd. When I came to prison I learned how to love me, how to care about myself. Now I can go further and help others. If I make mistakes, I let them be my mistakes. I like who I am now. I didn't like me very much before.

Just because you're in prison doesn't mean you have to be hard and cold. Sometimes the smallest thing like a smile or a word of concern can lift someone so high. I refuse to let this place make me afraid to be human. I refuse to walk around here with my head hung down, and I refuse to let authority strip me of my pride and my dignity and my sense of who I am. I may be an inmate, a prisoner, whatever label you choose, but I am a person first.

I was a "stuffer," and I'm still not a person who will cry on people's shoulders. I'll bottle stuff up inside. But when I need relief, I go to the place where I don't have to worry about what I tell. I go to God. I pray about it. I can cry in front of God, I can be naked to the world, and God will care and not judge me if I cry.

Whatever life brings, I want to take it head on, to embrace it, to disclose its mysteries. I want to do all those things with life, even in here.

Women lifers are like an invisible entity. It's like no one knows we're here. You read all the time about the men lifers—their graduations, the things they have. When we graduate, it's not in the papers. We're here, but no one really knows we are here.

There are so many victims. The person who it happened to is the victim, our families and children are victims, and in reality we're victims, too. There are a lot of talented, beautiful women in here who are going to waste. I believe deep down in my soul that with all our experience and influence, you have right here in prison what might help our next generation.

CYD BERGER

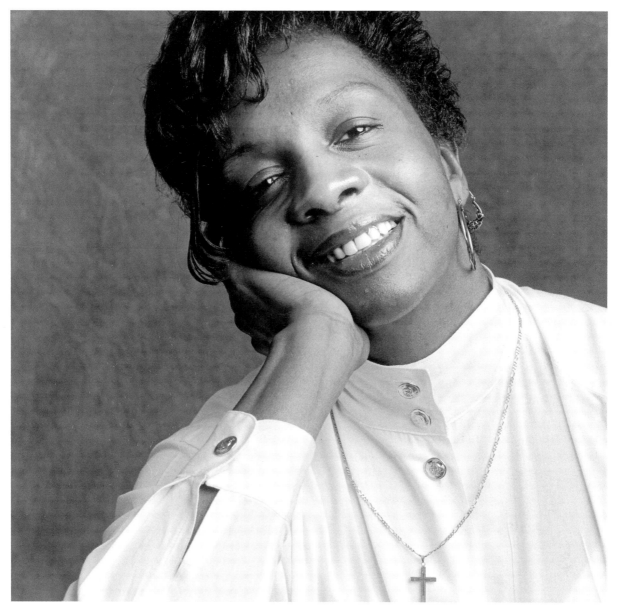

CYD BERGER

"I've missed seeing my kids grow up, going to their baseball games. Its little simple things like taking a bath or opening up my own refrigerator, being spontaneous, that I miss.

"After I came to where I felt comfortable with Cyd, I reached out. Sometimes I just go against the grain and hug and hold and touch and let people know that someone cares. I didn't leave my feelings at the gatehouse when I came here."

The picture below was right after I went to prison in 1971. I've been in prison for 26 years. I was 17 when I was arrested.

I was very rambunctious when I was 17, and I took a lot of things for granted. My life sentence didn't really hit me until a few years later.

At first I took every opportunity to run around and do the things that young kids do, like play ball. I didn't care much about my case at the time. Law, education, all those things just didn't matter.

I was the same way on the street—took everything for granted like I had forever to do whatever I wanted to do. And that wasn't much, because

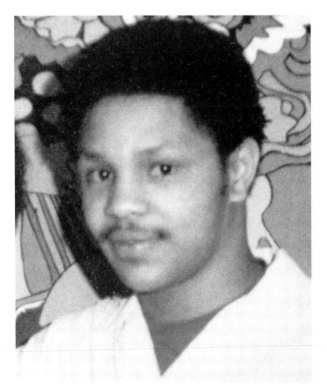

young **JOHN FREDERICK NOLE**

my mind was focused on just the immediate.

But I began to see that I really needed to do something with my life, that I was a little more capable than I had given myself credit for. About four years after I came in, I started changing my life around. I had started going to school, and I passed my GED. That was significant; that was like a milestone for me. It made me feel wonderful. It was the first time I had the opportunity to make my family proud of me. But more than that, it allowed me to see what I was capable of as an individual.

I didn't know that before, because I was oriented into a lifestyle where nobody achieved much of anything. Sports weren't that grand of a thing, and we didn't constantly see people becoming lawyers and doctors. We looked up to nobody. We didn't have any heroes. Black history was almost nonexistent for us. I had to come to jail to learn about what blacks did in history.

I don't know if I had any self-esteem on the street. I did things mostly according to what the group of kids that I hung around with did. I never tried to differentiate myself from them. I didn't say, "Freddie is an individual and I don't need to go and rob; I don't need to go and steal." None of that came into play.

There was no real thought. There was no pausing to stop to try to rationalize what was right and what was wrong. Even if you knew it, you did whatever was popular. My own sense of identity didn't exist on the street. That's probably why I got in trouble. That sense of identity did not come for me until I came to prison. I was just a member of the gang.

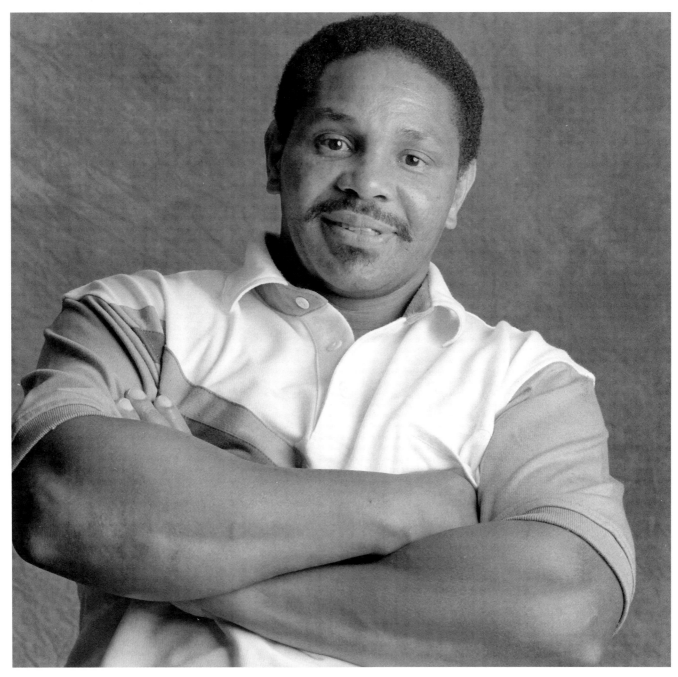

JOHN FREDERICK NOLE

Then I got educated. Education has made me everything that I am today. It allowed me to see how wasteful and nonproductive the life was that I had in free society. If I could take 17 years of my life and throw it in the garbage disposal, I would not even refer back to it.

My education started with the old-time prisoners down at Graterford. You couldn't be around these people and not know things. All of them had struggled for every bit of freedom and independence they had. I admired these guys who had been in the penitentiary and survived. Everything they did, regardless of how minor or how insignificant somebody else thought it might be, it was significant to them. They took pride in their jobs, mopping hallways, cleaning clothes, shining their shoes, keeping their appearance together, staying healthy and strong—all these things mattered to them. There was no insignificance about their existence.

At that time, jail was pretty much in the dark ages. You weren't allowed to have certain kind of reading materials. If you did, you had to read it somewhat underground, and I used to watch guys pass 50-60 pages of a novel down the line. By the time it got to the last guy, the book was back together again, and that amazed me. And it made me say to myself, "You can do something like that."

And then there were guys telling me, "You are young, man. You are not going to do forever in here, you understand? Get your education. Learn whatever you can." They used to tell me the basic three things that they wanted me to do was learn how to read, how to write, and how to type.

The first novel I tried to read was *Manchild in the Promised Land* by Claude Brown. It took me three weeks. There were words that I couldn't understand, and this dude Jim told me to write them down. There was another who was on death row and had gotten off once they abolished the death penalty. He would give me these American tablets filled with words, English composition words, and he would say, "Look, I got 30 of these. Now when you get done with one, I'll test you, and then I'll give you another one."

This is how my education started. This is when I started distinguishing myself from people I had grown up with. By the time I was about 25 or 26, I was chairman of the lifers' organization. I just never stopped growing from that point on. Nobody ever made me feel that I wasn't capable of achieving something, even friends from outside.

I've had a friend named Linda for about 23 of the 26 years that I have been here, a schoolteacher, educated. She never made me feel as though I was anything other than a capable, intelligent, articulate individual. If I wasn't, she treated me like I was and showed me by example that I could be more.

Another person is a professor of political science at Lincoln University. She encouraged me to read poetry I had written. Like I said, I just kept going. I never felt as though I couldn't do anything.

The other night, I was looking at a TV interview with Colin Powell. As soon as I saw this man, the first thing I said in my mind was, "That could have been me." I look at the superinten-

dent here and I say, "That could have been me." I don't feel any less capable of achieving the things these people have achieved than they are. The only thing that stopped me is that at an earlier stage in my life, I didn't have a correct perspective on life and what I was really capable of.

My lesson from all this is that if you want to change a person who's lived the kind of life I did, you have to remove them from the environment where they are not learning anything. One of the downfalls of all the different times that I was removed from society was being sent back into the same environment where there was not enough supportive mechanisms to keep old patterns from manifesting themselves.

I had good opportunities when I was away. For example, I went to a place when I was about nine years old until I was about 11 where we had house parents and went to school on a regular basis. We had chores, all the things that kids should learn. We would earn money that we could spend in the commissary. We would go to the movies, we would go to skating rings, hiking, we would have what they called corn roasts and things. We had sing-a-longs. All these were good, nurturing, wholesome American things to do. But when I came back to the inner city of south Philadelphia where I was born and raised, nobody around me knew any of these things. There was no camping, there were no corn roasts, no fathers and mothers taking their kids fishing.

Gradually, everything that I learned and that was meaningful to me and that I liked had to be thrown off. And I had to start adapting once again to the lifestyle of the people that I associated with, even to the point that it was good to be dumb.

All the good habits of studying and learning in school I had to shake off, because if you were too smart, people made fun of you. Without any self-identity, you succumb to that. It was the same thing every time I went away and returned to the same environment. This is the first time in my life I have felt that if I am ever released, I have the understanding, I have the emotional stability, definitely the intelligence, to say, "No, that's not what I want to do."

I got married in 1984 when I was at Graterford. I had never been in a relationship with anybody, because as soon as something happened, they were no longer there. So once again I figured, if you are in this woman's life, enjoy it for the moment because it's not going to last. We put no faith in it, so we didn't do any real nurturing. My wife was the first one that showed me that you can have rough times, you can have insecurity, and yet stay where you are!

With that type of education, I now believe wholeheartedly in monogamous relationships. I don't even care about how good another woman looks or whatever another woman may be able to offer me, because it is not important. What's important is that I have somebody who cares enough about me to stay in my life, in spite of the situation I am in. This has taught me more than anything I ever learned elsewhere about relationships, about being with somebody and really loving and caring about them.

I don't even listen to dudes. I mean I hear

guys all the time telling me, "Man, there ain't no woman out there in the street that ain't doing nothing, man. They are all doing something." Well, I can say wholeheartedly right now that I know my wife ain't doing nothing but loving me and caring about me and hopefully trying to find a way for me to get out of here. There was a time, though, when I said, "Oh yeah, right. Out of sight; out of mind." I don't believe that any more because of my wife. You understand? Just because of my wife.

I learned empathy mainly through interaction with other people. It means always being able to put yourself in somebody's shoes for a minute, because nine times out of 10, you've already been there. The biggest thing is not being afraid to say you've been hurt. Another thing my wife has allowed me to experience is being able to say things like, "I'm sorry, I love you, I care about you." It was hard, but my wife made me understand there was nothing wrong with that.

I hadn't had examples of that before. I don't believe I ever heard my mother and father say they loved one another. I cannot remember ever hearing them say to each other that they were even sorry something happened.

A friend of mine was telling about how stern he had gotten with his girlfriend a couple weeks ago because she missed the bus to visit him. He said, "I'm going to write her a letter." I said, "No, don't write that letter; don't write that letter." But he wound up writing that letter anyway. A couple of days later he said, "Why didn't you want me to write the letter?" I said, "Anybody can make a mistake. You know she wanted to see you. She already paid for the bus to come up here. That should have told you right then and there her intentions were good. The thing for you to do would have been to console her and let her know this wasn't going to make or break your relationship."

It's not necessary for men to show their wife—or their woman or anybody that cares about them—that they are men. We get so oriented in prison about expressing our manhood. Everything is, "I am a man, I am a man, I am a man." We forget that with our women and people who love us, we don't always have to profess that in everything we do. The profession of your manhood is overboard when you are insensitive. This somebody who loves you and cares about you and probably would do nothing to hurt you is not the jailhouse element you always deal with. They are not trying to break you down; they are not trying to make you insecure; they are not trying to show your fallibility. That was a problem with me—always feeling my manhood was being attacked. That makes you insensitive.

I spend a lot of time analyzing my growth and development. I do it because I want to be of value when I get out of here. I don't want my life to always show that I've been here. I would like to be able to sit down with somebody and have a full conversation and then say, "Oh, by the way, I just got out of prison, you know." Let it be a surprise. I don't want the jailhouse jargon. I don't want to treat people the way I've been treated since I've been here.

Here you can't even be human. You can't make mistakes because you pay for them very

severely. In my 26 years here, I paid for a lot of just human things. You have anxieties, so you say to a guard, "Get the hell away from me." The next thing you know, you got a misconduct and you're spending 30 days in the hole. It doesn't even have to be violent or profane. It's just a matter of losing your temper, and all of a sudden it is disrespectful to staff. But it's a human thing to be agitated.

Once they had just killed my brother in the street, and a guard thought it appropriate at that time to harass me and my wife in the visiting room, and I told him off. I wound up spending 30 days in the hole and losing my visitors for 90 days. There was no excuse for it, but I was under a little pressure. I just got news that my baby brother had been killed, and I said to this officer, I didn't understand what he wanted. Thirty days. Loss of visiting privilege—90 days.

In 1987 I received the Spirit of Philadelphia Award for the creation of the Parent/Child Resource Center. I had been allowed to go back outside and work on the farm as a clerk in the dairy processor. We were setting up for a walk-a-thon, and it was snowing or raining, something like that. We asked to be able to set up the chairs and hope that the weather would pass. One lieutenant said, "Yes." Another lieutenant countermanded him, and I wanted to know why. And he said, "Because I said so." I said, "Well look, man, just because you say it, don't make it right." That statement got me 90 days in the hole because he said that my manner threatened his person.

And then, in '89, I was accused of grabbing a child in the Parent/Child Resource Center.

Without having the opportunity of ever defending myself, I wind up here in Huntingdon.

So these are things that I have really had to bounce back from on a number of occasions. But once again, my self-worth and who I am as a person have not allowed those things to overshadow and stop me from showing what I am capable of. I've been given the opportunity here at Huntingdon to basically re-group myself. To some extent I have been able to continue my advancement in the system—it's not been all in vain. But it's been a difficult six or seven years. You definitely got to wonder how long you can keep it up.

The only thing I regret about my prison experience is that I've been here so long now and haven't been able to put a lot of the things I've learned into motion in the larger society.

JOHN FREDERICK NOLE

KEVIN MINES

"Waking up not knowing what the next day will be like, whether you could be in a riot or get hurt, is scary. But the real dread is of losing your family, your loved ones."

HARVEY TELFORD

"Music has been the thing that relieves the stress for me. Music has taken the bitter taste off incarceration. Music is my savior."

It's a tunnel without light at the end. It just goes nowhere. An endless black hole that keeps sucking everything in. That's all this place does—just sucks you in and keeps you here.

What makes it tolerable is hope. That comes, I guess, from within, from the people around you, from the friends you develop while you're in here. You can't exist without hope.

The Family Resource Center [in the visiting room] is the whole basis of my existence right now. I consider myself fortunate that I've been able to interact with kids. I love my own son, but I don't see him, so I feel fortunate to have this. It gives me hope. A lot of bright-eyed kids—they give me energy. A lot of them are starving for affection, for love, and they don't get it from their parents. So we end up giving it, and we don't mind a bit!

Working with kids helps you turn around because they are always looking to you for guidance and direction. You're the role model. So I've come full circle since I've been here. I came in wild with an attitude like, "You can't keep me down. I'm not going to be here long." Now I think more. I'm more conscious of where I'm going. My self-esteem is higher, and I like to reflect.

I don't like my cell. I sleep there—that's it. Other times I'm at work or somewhere. It's a dark cell with painted windows and they turn the lights out. I do use a night-light, but I don't like a whole lot of light in there because I don't like the place. It pulls me down, so it's just a place to sleep and get out of.

A lot of funny things happen in here. It's hilarious because you have such a mixture here. The guards themselves wander around in a daze, handling keys; then they drop them. It's instant panic because they are told that if they lose the keys, that's it. So as soon as you hear a key drop, you see this guy scrambling. This guy is expecting you to grab them. When you see that, you don't just bust out laughing. You walk by with a nice chuckle on your face, trying to keep your composure.

Once there were four of us just sitting out in the visiting yard, doing bubbles for the Family Resource Center. I made the concoction so heavy that the bubbles were heavy. They wouldn't bust. They were going from the visiting yard out into the main yard, just floating by. "Where is that from?" People talked about that for awhile, this unbelievable bubble going through the yard. Cracked us all up.

BRUCE BAINBRIDGE

BRUCE BAINBRIDGE

"I think about a lot more things than I did before. I see more sides to things. Not just one side, my side. I've learned to put more credence in the other side of things."

I was naive. It was the first time I was ever in the court, ever really in trouble. When I got sentenced to life, I didn't realize that it was my entire life—even hearing them say, "You'll be sentenced to your natural life." Something in my heart said, "That's only a period of time." But after a number of years and talking to other lifers, I realized what it is. It's for the rest of your life, until you die. The only way you'll leave is when they carry you out. It seems so distant and unreal even now.

It's like a bad dream, a nightmare. Having killed somebody and receiving a life sentence— there's no coming back from that. There's no hope as far as man is concerned. But my relationship with the Lord gives me hope. About six and a half years ago I received him as my savior and repented for what I did. A real change happened in my life. A big burden was taken off my back. A big weight of guilt left, and that is my hope.

We have other Christian brothers in here, others who know the same thing I know and who have faith in someone greater than ourselves. That's a common bond and a fellowship and a family. We can rely on one another.

EUGENE MCGUIRE

60

EUGENE MCGUIRE

"I think the accomplishment in my life that stands out is the realization that I have the ability in me to make decisions good and bad. I don't need anyone else to live my life; I don't need to blame anybody else for the choices I make. I guess I never thought about that before."

I've gone from the James Dean look to the prisoner look!

When I was 19, I wasn't sure what was going on. I had no idea that I was going to be convicted of a first-degree murder offense. My rap partner confessed to the crime itself, so I figured it would be second-degree murder for me, which at that time carried 10-20 years. But with the way I was sentenced, I probably would still be here on the other charges anyway. I had five charges. Now I've been in prison for 34 years.

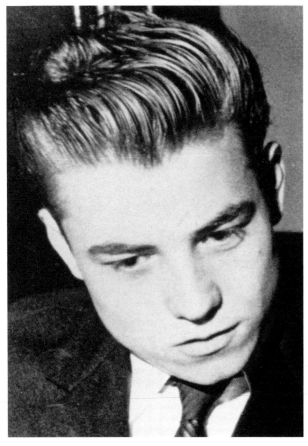

young **DONALD MONTGOMERY**

When I was around my responsible friends, like my family and so forth, I was great. I was good. They all held me in high regard. But when I got around other people, I began to act like them—reckless like they were. At home I was reserved, but it depends what environment I am in. If I am pushed into a good environment, then I'm good. When I am pushed into a bad environment, then I'm bad. That was then, though, you know. Everybody said I was a follower. I look back now and see I certainly was impressionable!

Maybe I was just looking for recognition, for acceptance, because I was small. I was just a runt, so I was always with people who were bigger than I was and who did crazy things like riding bicycles down mountains standing on the seat. No brakes on the bike. Really dangerous things. Probably looking for respect.

I didn't know what self-esteem was; I would just go along with the program. It's a wonder I'm even here; lucky I wasn't killed as a kid, with some of the stuff I did!

Now I am a caring person, a helpful person, no trouble. I haven't had a misconduct since 1972, and that was an escape charge. I think I am held in pretty high regard in the jail among my peers and among staff, because I cause no trouble. I try to patch trouble up. I try to educate my peer group, which is a lifer group.

I almost have a caseload around here, you know, as far as talking to people, trying to straighten people out, just trying to prevent trouble, real serious trouble, fights. So I am a referee-type person. If someone comes to me, I

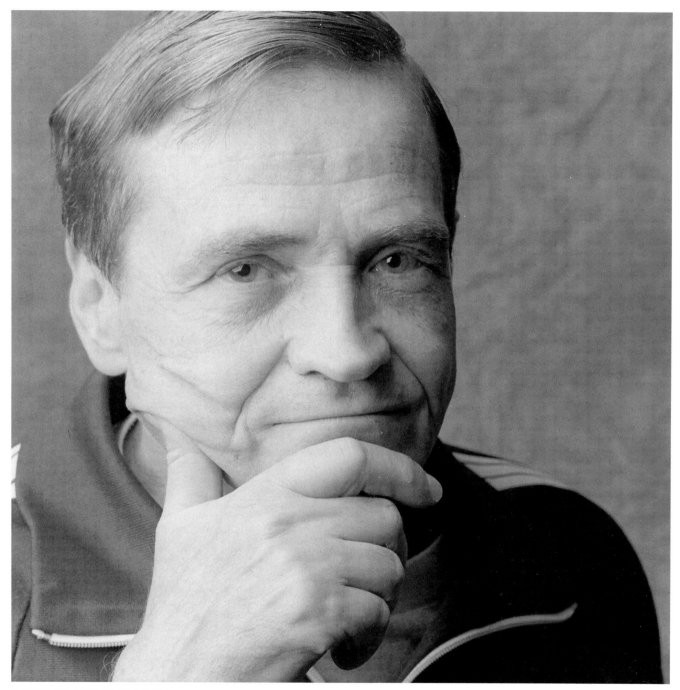

DONALD MONTGOMERY

won't turn them away. I am there for them if they want me.

That 1972 escape charge was the last of my trouble. It was a gradual thing. I thought, well, Donald Montgomery has the worst case. He has the least likelihood of ever getting out. Why should I really care that much?

I found out there are people worse off than I am who aren't even doing life sentences. We had people here doing 50-100 and more, and I look at the poor guys on death row, with the governor who evidently wants to kill them all.

What made me change, I think, was my realization that if I ever wanted to get out, if I wanted people to hold me in any kind of regard, I couldn't be a troublesome prisoner. I had to straighten up my act—and I did. But even that was gradual. Even when I was no trouble, it was a gradual thing. I was sour grapes for years, until I finally found out that other people were in a worse condition than I was.

I went up for commutation—this is my 19th application, 19th!—and I was recommended 10 times to the governor. I have been on the governor's desk 10 times. All 10 of those were denied without comment. The system said I was ready since 1980.

What keeps me going is the realization that sometime, at any age, I am going to get out. I am looking to get out. And I hope this is done pretty soon before a lot of my family die off.

You can look at this picture, and you don't know if this guy is doing well, or if he is doing badly. Is he going on with the program? Is he trustworthy? You know, this really doesn't show you anything. A picture doesn't show you nothing!

DONALD MONTGOMERY

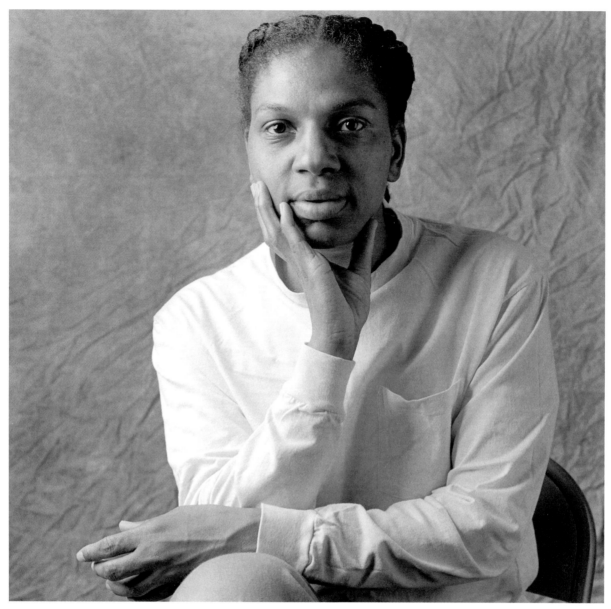

TRINA GARNETT

"It's like a rabbit up in the corner that can't get out. It keeps trying, but eventually it just dies there.

"I was running wild, like an animal. I was violent because it seemed nobody understood me. I couldn't explain myself and it came out like violent storms. Then I started getting in touch with myself by being alone. That's what made me happy, so I just stay alone."

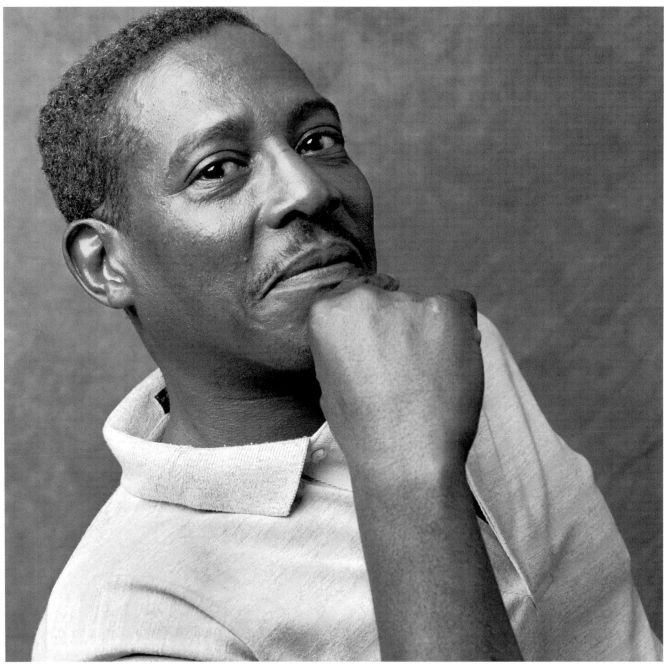

LEONARD WOMACK

"The worst part is thinking about dying in here, to feel like nobody knew you. Nobody knew who I was."

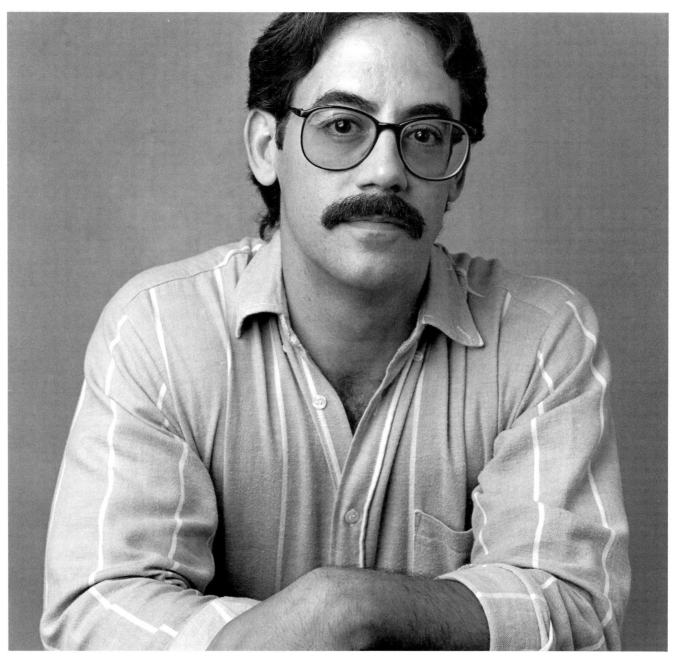

CRAIG DATESMAN

"The one thing I really miss besides family and children is not the sex, but the ability to love, to share your life with someone else. That gives you reason to live. Here you're doing it vicariously through letters or phone calls."

My oldest granddaughter, little Megan, precious child that she is, says, "Ma-maw, you have such a big house. Can I sleep over?" She doesn't realize what she is saying. This is okay when she is three or four, but what am I going to say when she's six or seven? I told my daughter, "I just don't want to lie to her." I'd rather tell the truth.

I have a beautiful family. My grandchildren—who I can only watch grow on photos and not be part of—that's where it affects me the most.

But when it comes to me, I used to *do* life but now I *live* life. I know that I must make the best of the circumstances that I dealt myself. But it's time I expand beyond these fences of steel and stone that have served their purposes. It's now time to think about returning and saying, "I'm one of the two percent or whatever that get out." I want to be part of that number, and that's what I'm working toward. Commutation is an almost fruitless process, but I still hope. As long as I have that, I will keep going. But if you talk about getting out of here, you must make a difference in your own environment here.

When I came here, I didn't think there was anything wrong with me, but with everybody else. I know today I'm a far better person than I was. Now I understand not the *excuses* of why it happened, but *why* it happened. It makes me be able to accept myself without blame or without using someone else as a scapegoat.

I know what I allowed by my codependent actions, by my need for someone else, by my fear of abandonment. Today I'm a healed individual. I'm more understanding and compassionate, but not to the point of letting someone use me again. I'm a supportive individual, but there's a limit to my being able to give beyond my boundaries. Before, I didn't know I had boundaries.

I remember the first question the psychologist asked. He said, "How's Betty?" and I said, "Betty who?" I was always Mrs. Heron, somebody's sister, somebody's mother. Betty was not there. I did not have an identity. It was frightening when he reminded me later of what I said. It gives me hope to see where I am now. I just hope that I can convince someone else that there are some redeeming qualities in this woman.

A life sentence is a glass bottle. You're planted in this foreign soil, this cultural abyss. They want you to grow, but in growing, if you aren't careful, you begin to take the shape and form of your environment. One of my proudest accomplishments is that I have managed to grow without taking the shape of my environment.

BETTY HERON

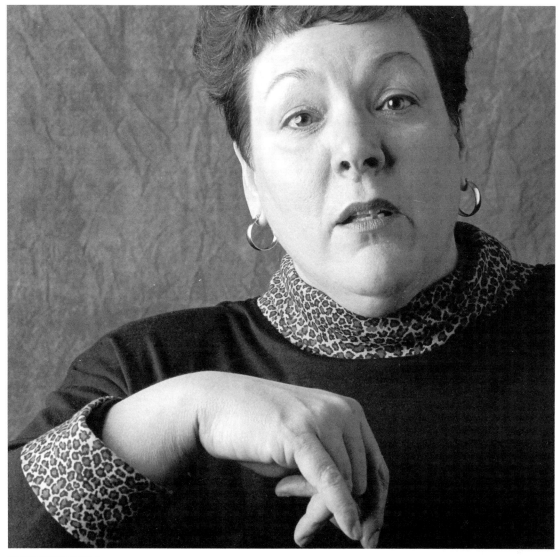

BETTY HERON

"I've watched my family marry on videotape. That was hard. My name wasn't even on the invitation of the last one. I asked my son why and his answer was, 'Because you weren't there when I needed you.' I can't argue with him, but it hurts.

"I believe I've been forgiven by my God and myself, but it's the forgiveness of the family of the victim and my family that's the problem. I'm deprived of the opportunity to face them. Justice is a blend of justice and mercy. You need to be deprived, but you need to be restored."

I've been able to accomplish things in prison in America that people would never accomplish in a lifetime in other societies. Having been in the military and traveled abroad, I do understand that. But a life sentence is cruel when we know that souls of men can be redeemed. Most lifers go on every day proving it.

To be punished forever doesn't sit too well with the values that have been ingrained in you. In America, all things are possible. When you give a man life in prison without possibility of parole, that doesn't fit within this society. Forty-seven other states recognize that people can and do deserve other chances.

A guy could have been part of Saddam Hussein's mob and been at war with you. Now he wants to come to this country and he can. He will go through the citizenship process, and they will not treat him the way that they treat me.

I can't change what has happened. What I can do is guarantee you that it doesn't happen again with me. And what I can do is deal with other people and try to prevent them from running into the same pitfalls that I ran into. I feel that I am accountable for every day, for every minute I breathe. I have a purpose. I do intentional living.

One of the things that bothers me more than anything else is the tag of being a murderer. I just absolutely detest that. I don't practice that. There are other things that I do on a regular basis. Call me *that*. I love people every day; call me love. Don't call me a murderer. This was an episode that took place once.

I went out on an escorted leave in 1987. The deputy superintendent and I were standing at a red light in the crowd. I was in a gray, three-piece Brooks Brothers suit with an attaché case. I'm wondering, "Can they tell?" There were people on the other side of the street that I started talking to, and they wouldn't believe me. I invited them to come to the College of Physicians where I would be speaking. I said, "I'm telling you, I'm a prisoner and this guy is escorting me." They wouldn't believe that. It made me feel kind of good that there was nothing about me that resembled a criminal, whatever a criminal looks like.

RAYMOND CRAWFORD

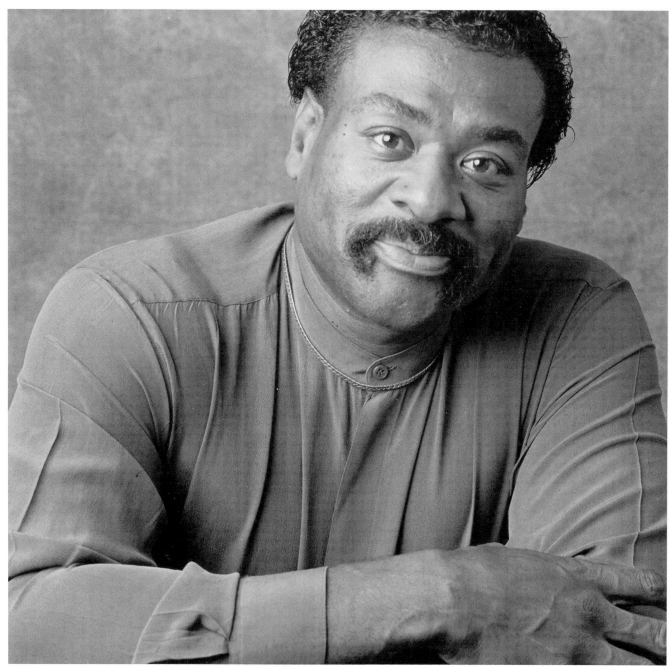

RAYMOND CRAWFORD

"You watch your family grow up. My son was five years old when I came here. Now he's 28. He has a family. That takes a toll on you."

Since I can't seem to get myself out, maybe I can stop my daughter from coming in. I didn't get a chance to do that with my son. He was four when I came here and he's in prison now, and that just tears me up. I can't imagine sitting here in Muncy with my daughter! I don't want that, so I'm doing everything I can to help children get the aid they need to prevent them from coming here.

Right now the main thing that is keeping me going is a task force that I'm trying to start called Children of Incarcerated Women. One day I hope to see a support group in schools for these children of incarcerated parents. That's what is going to be filling up tomorrow's prisons if we don't do something about those children.

They're psychologically messed up because of the separation from their parents, and nobody is paying attention to that. We have advocacy groups for the victims we victimize directly, but those groups don't cover the victims that are forgotten about—our children.

MARIE SCOTT

A resolution to study the needs of children of incarcerated parents, which Marie Scott helped write, was introduced by five senators into the Pennsylvania Senate in October, 1993.

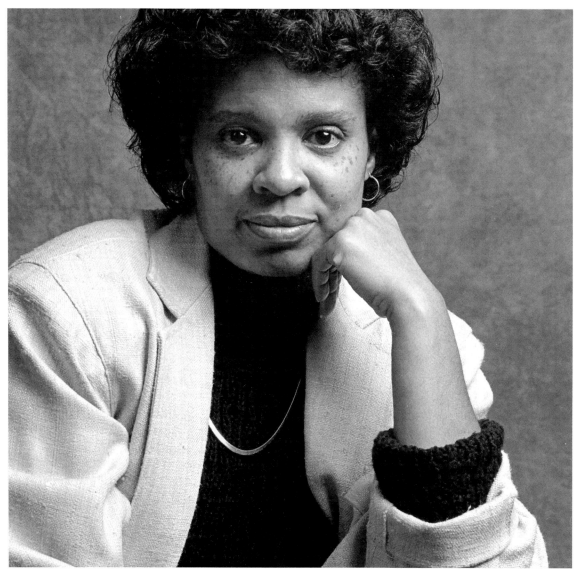

MARIE SCOTT

"I'm being punished for something I did, but I'm not being allowed to try to do something about it—helping my victim's family. That's the most frustrating part about a life sentence, because I do have a conscience.

"I had nightmares when I was a child, because I was sexually and physically abused. Sometimes I'd wake up and couldn't tell the nightmares from reality. A life sentence is like that. I go to sleep wishing it wasn't true, but when I wake up, it's not just a nightmare. It's reality."

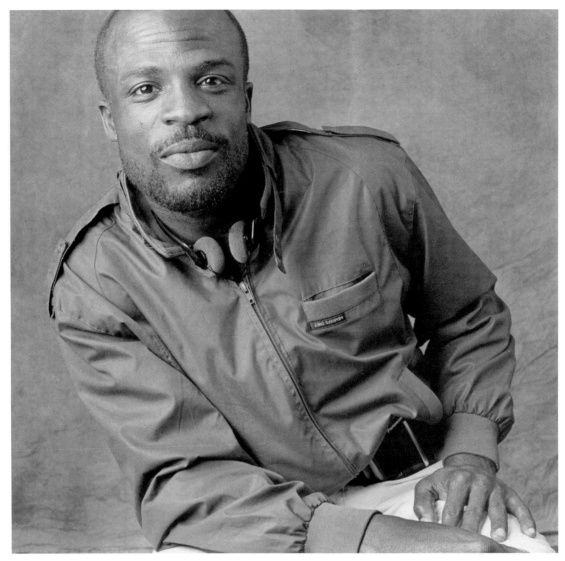

FRANCES BOYD

"If you think too much about the letters L-I-F-E, you might go crazy. So I keep myself occupied. You have to make each day count.

"My first five years were the slowest part of doing this time. After that I started getting involved in programs and I woke up.

"I get depressed around the Christmas holidays or after visits. I think about my family, and at night in my cell, I cry. I get it out and then I'm alright.

"I'm a humorous guy and a practical joker. And there's a lot of funny things going on in here. Humor takes away a lot of stress for me."

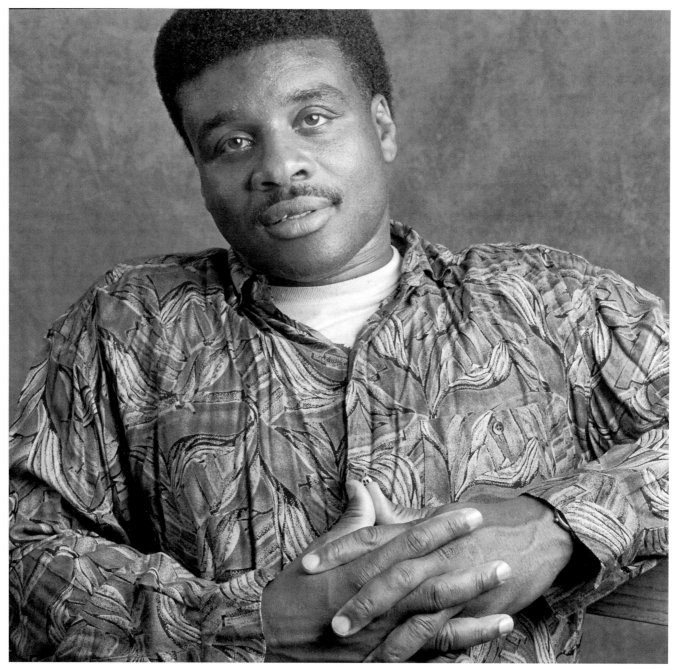

FRANKIE LEE

"If you don't believe human beings can change, you sell humanity out."

The longer you are in here, the less ties you have to the outside world. Your family begins to die off. And your friends—how long can someone really stand behind you? They eventually just go back to their own lives. That's sad. That really hurts.

But it's also been my choice to decrease visits. They're hard for me. When my father visits, it's hard for him to see me in here, and its hard for me to see him leave. The fact that he's alone out there doesn't help, because I feel my place is out there with him. You feel so helpless because they support you in here, not only morally but financially. It's like being a child again.

I've gone through stages. There was a period when it wasn't hard, because the life I had before was rough. When I came to jail, I was safe for the first. I didn't have to worry whether this was the day he was going to kill me. Now it's getting really difficult. I've done everything I can do here. I've taken every opportunity the prison offers.

I'm a touching person. If someone's hurt, not feeling well, I want to reach out and hold their hand or give them a hug. You can't do that here because it's looked on as a sexual thing. You get so paranoid. You have to stop and double-guess every little thing you do. And the rules change so often. What might be wrong today might be okay tomorrow.

Some people say it is this way in the free world, too. But you still have some choice. If you don't like your job, you can leave it. You have the choice to make. You don't have that here.

I come from a strict Catholic background. You didn't get divorced. You live in the fear of God, and the guilt tears you apart. They didn't teach you about a loving God. He's a damning God. Now, since I've joined the Quakers, I've changed.

I don't have any major dreams. I just want to go out and be with my dad because he's getting older, and I don't know how long I'm going to have him. And I have a relationship with a son that I need to get together, to mend some fences. I haven't seen him since he was six. That would be one of my first contacts if I got out.

There are a lot of inmates in here who look up to me. I'm sort of a role model, and that helps keep me going. And my supervisors put a lot of trust in me. I have a tendency to mother young girls that are coming in. It's probably because I really never finished experiencing my own motherly instincts with my son. That's important to me, and I do it a lot.

I don't know where they're getting these women, though. When I first came here, you were scared to death. These women now, they walk down the sidewalk like they're coming to a resort. They're rambunctious, they're loud, they're arrogant. I know I've been locked up a long time, but if this is any indication of what things are like out there, it's scary.

Most of the women that work on the prison farm have a certain cow that they take as a pet and name and spoil it, take it apples. I always have one, and my cow just gave birth. I'm a grandma! And I'm just tickled pink. I'm in here telling everybody I just had a bouncing baby bull!

I like the farm because you can go out and hug the cows and tell them anything that you want. And you get affection in return. I spend a lot of time with the cows.

DIANE WEAVER

Since this interview, the prison farm has been closed.

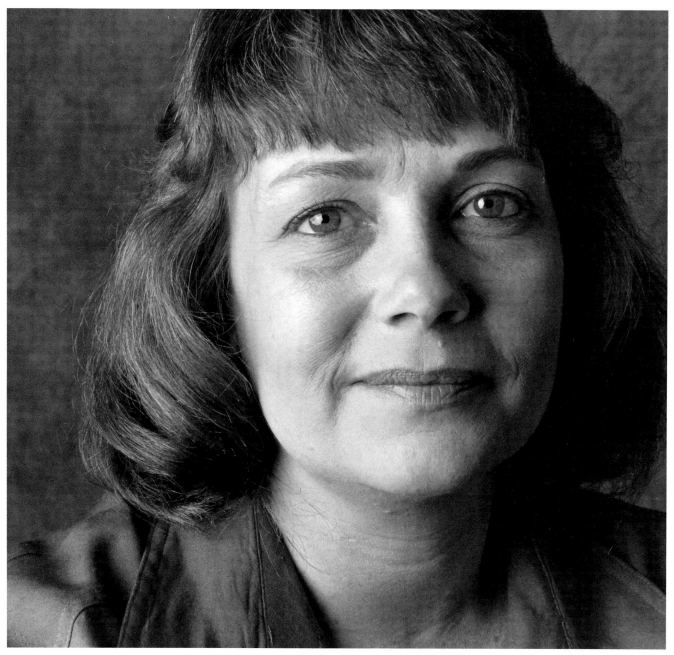

DIANE WEAVER

"I lived in a prison in my own home with an abusive husband. When I first came to jail, it was a refuge. I didn't have to worry whether he was going to kill me. But it didn't take too long for the reality to set in."

It's an ongoing struggle every day to try to make something out of nothing. It picks at you piece by piece. It involves a lot of sadness; it's a stressful situation. It takes a toll on the family. You see things chipping away slowly but surely, and that tears you to pieces. It picks you apart.

You may have some community and family, but you need more than that to really keep you all together. You got to have something greater than yourself. That gives you hope to get up each day and perform like a sane human being, and not to be what you have been labelled to be—some vicious killer.

What a guy's in jail for probably only took a few seconds. That's not the whole person. That's just a couple of minutes out of the person's life. There are more dimensions to that person. I think we're wasting thousands and thousands of people by just writing them off as no more good.

Sometimes there is good news in here. Someone gets a new trial. Or a guy may share that his daughter had a wedding or that he has a grandson or granddaughter. Or some guy's graduated from school, gotten his GED. That makes my day brighter. Or I get a card. Then we might have a good meal. We'll talk about it and laugh.

You'd be surprised. It's a community right here, and there's enough mature men that they make the day go. They make the day constructive. They talk, they gossip, they complain to one another. So we have community here.

At 9:00, though, when we go into lockup, that is the worst. Then I am probably the most miserable person, at 9:00 when I go into my cell. I'm reminded that I'm locked up.

You see a lot of masks on the men, the administration, guards, even on your own families. I've studied the different masks, and I know how to deal with the guys. And I've got little masks on, too. But I don't hide it. I speak about it and I try to get guys to talk. I've found guys that got stuff bottled up. I know they're suffering the same thing I'm suffering. I've gotten a lot of guys to open up.

A lot of funny things happen here. A guy patted a female guard on the butt, and she slapped him, knocked him down. I'll never forget it. She handled things real perfect! Or a guy snaps out in his cell, burns everything up, runs down the tier with nothing on. That would be the talk of the jail.

CHARLES DIGGS

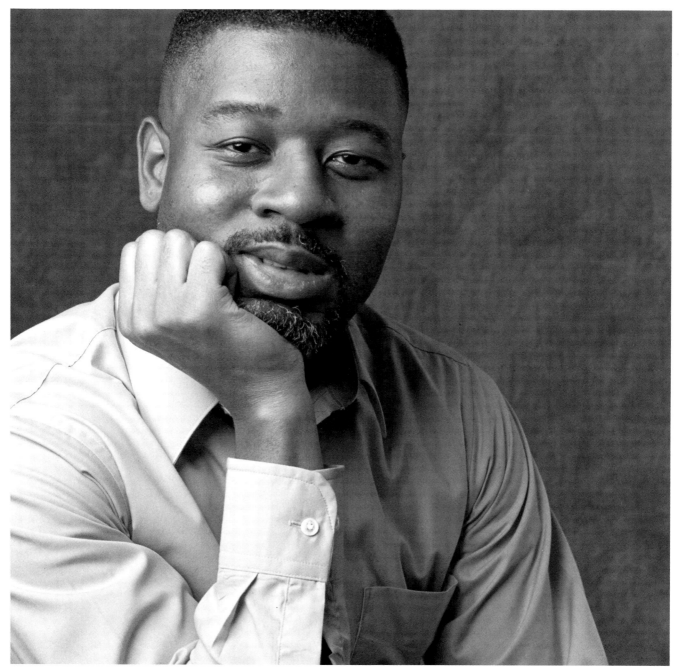

CHARLES DIGGS

"I think about the 16 years—how did I do each day? I don't know. But I know every day I got to make it a good day, even though I cry each day, too."

I was a rather straightlaced, conservative, rural schoolteacher when I came to prison. I don't think anyone would have considered me really impetuous and crazy back then, although probably one of my downfalls was that I had a bit of a temper. But I am not so sure, as I look back on it, that I had much more of a temper than other young men my age. I haven't

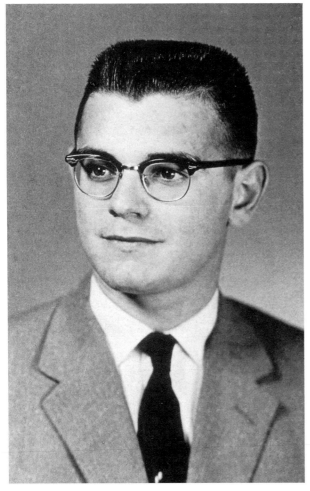

young **JON YOUNT**

retained it over the years, or at least I've dispelled it, so I'm not sure.

I've watched all the young guys coming into prison now, and they seem to be able to explode on a moment's notice. I see myself that way. Normally it was the type of thing that was directed at inanimate objects, like to slam a door or whatever. I don't think most people realize the potential for violence they have in them under the right circumstances.

I taught math and chemistry and those types of subjects in senior high school. I thought I did a pretty good job of it. I've received a lot of comments from my former students during the years I've been in, and most of them seem to have perceived me that way. There wasn't one of them who didn't see it as far out of character for me to react as I did so that I ended up in prison.

When I see that picture of me 20-30 years ago, I see a person that looks almost like my son now. I have a son that is 32. He was three years old when I came to prison. My daughter, who is now 30, couldn't even walk yet. So more than these pictures here, if I really want to see what the passage of time looks like, I look at the pictures of my children when I came to prison and what they look like now. That really demonstrates what 30 years looks like.

In the picture of me today, I see a person who is a lot more cynical and a lot less trusting of people than the one 30 years ago. I grew up in an area where we used to keep our doors unlocked and you trusted everybody. Now I'm in an environment with other inmates who have a tendency to take advantage if they can.

JON YOUNT

Of course, not all of them do that, but there are more here than you would find if you were in a community somewhere else.

But it's also the system. I just do not trust the system very much because I've learned that it's so political. It has little to do with what you've done and little to do with who you are. It rides on the waves of the attitudes of the public and politicians, and we are in a real trough of that right now. That's what leaves me so cynical and not very trusting of people generally. I've become suspicious. That's not the best way to be, but I don't know how you overcome that.

My mother, who is elderly now, comes to visit regularly. Every time I see her, I see someone who has probably spent more time in prison—in the visiting room—than a lot of people who commit crimes. I look at her and I see what kind of pain she has gone through. It makes it easier to identify with the pain of victims, with the mother, in this particular case, and what she has gone through.

I think I always was an empathetic person, but not to the degree that I am now. For a young man, the world centers around you. As you get older, you find out that's not true.

Remorse is a big term with criminologists and correction people. The Parole Board, the Board of Pardons, always emphasizes that you must demonstrate remorse. I am not sure how you do that after 30 years. There is a time when remorse is at its maximum, but I don't think it is 30 years later. Yet, if you don't demonstrate it successfully, maybe not even very truthfully, then you are not going to be successful in your applications for parole.

But if you just sit around all the time and try to find out what's wrong with yourself, instead of looking for some of the positive things that you bring to this world, you end up being a much lesser individual than you are capable of and than society wants you to be. Often the system is counterproductive in that regard. Remorse has always been a difficult term for me to deal with.

For the first four or five years in prison, I had a hard time living with myself. It was dealing with the psychologist that helped. We became sort of friends, and he really recommended that I start looking for positive things in my life and move on. I tried to do that. We started several organizations and I was an officer in each. I went to the institution at Camp Hill and got involved in the data processing program. We worked outside the fence and traveled to Harrisburg all the time. A different time and a different place than now, but that was the way it was back then. So going out and dealing with people in the community really made a change, too.

I don't think you ever get over feeling sorry for yourself, though. You don't lose sight of the fact that there are victims that have suffered more; when you are in for homicide, the primary victims have suffered much more than you. But you definitely do feel sorry for yourself and try to second-guess why you made certain decisions, as spontaneous as they may have been. Why did I happen to be at a particular place? Why did I react that way? What could I have done to convince the jury that this wasn't the same crime as

the district attorney portrayed it to be?

Oh, you can get mired down, and many people do. That is a very popular approach to life in general in our society right now. People just do not take full responsibility for most anything they do. It's popular to be a victim.

People outside sometimes jump off buildings because they can't deal with life. In here, one way of committing suicide is to just shut down and turn on your television, lie there, and wait to die. Often people resort to that because of failures with the parole board, failures with their families. They don't get visits—I was amazed when the superintendent told our lifers' board that only 10% of the prisoners here get visits more than once or twice a year.

Then there are other people who just don't ever quit. They are the ones who accomplish things that are positive for prisoners in general. It's amazing that, in our allegedly modern philosophy of corrections, what prisoners are capable of doing is not recognized.

I kid with my supervisors that the correction system is one of the few businesses in which you are richly rewarded for failure. I was just walking around the yard with a young fellow who's been in an education program since he's been here. Because of misconduct or something, he was told he can't participate in the educational programs anymore until he gets back to a certain behavior level. Now that is why the system fails. They punish a guy by taking away his education, which is what he needs in order to survive in society. That kind of stuff is so counterproductive.

It's scary when you think that this is the fastest growing industry in the U.S. and it's based on failure. Why in the world would a parole board want someone to go into society with an attitude for having been forced to do the maximum sentence? That's not what society wants—somebody coming out with no supervision and with an attitude. You'd think they would bend over backwards to make sure that persons are released before the maximum so they have time to mellow out with some supervision.

That's what makes you cynical of the system. The person who gets lost in his cell and doesn't get involved in the world, who doesn't think about those kind of things—maybe he's better off. Maybe the person who suffers most from the prison system is the one who stays involved and tries to analyze what is happening, but is helpless to do anything about it.

I think anger is important and valuable in everybody's life. People need to be angry at times in order to demonstrate that they really have an adequate array of emotions to cope. If there is nothing that makes you angry, then you are so laid back you're probably not accomplishing very much in life. So I think you have to experience anger. The key is controlling it.

There are a lot of ways of dealing with anger and I think most people in prison become very good at that. It's an issue of survival, for one thing. But more than that, you have time to work at controlling your anger. I can definitely control my anger much more as I have gotten older. I attribute that to aging and to the environment. A person almost 60 years old can't be walking around here angry and survive!

There are things about me that I can't seem to change. When something happens, I can't go in, close the door, turn on the television, and ignore it, like some people do. Me, I have to confront. If I don't like something, I have to deal it. If it's filing a complaint, if it's filing a brief in the court, if it's trying to change something within the prison system—when there's something that bothers me, that's the way I deal with things. That's the way I try to deal with what I see as an inequity in my sentence. That's what drives me.

I also like to participate rather than observe. Even at my age, I have to go play basketball. I've had a hip transplant, and I still go and play softball and umpire. I just hate to sit around and watch; I want to be a part of it. That's something I need to change. It's very difficult to do.

What bothers me are people in prison who hang on to their dreams of the fast life. If you leave here, you are not going to have that kind of money. So you are going to have to sell drugs, or do something like that. When I listen to that kind of stuff, I think the person is not in touch with reality.

JON YOUNT

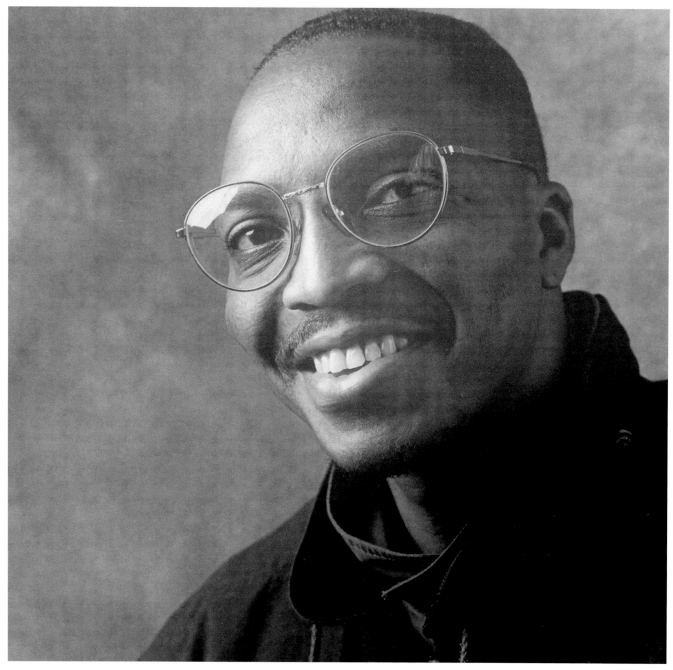

MICHAEL TWIGGS

"A life sentence is a very tall wall that you could continuously climb and never reach the top."

It's a slow, torturous death. Maybe it would have been better if they had just given me the electric chair and ended my life instead of a life sentence, letting me rot away in jail. It serves no purpose. It becomes a burden on everybody.

What keeps me going is that I have a strong belief in God, the Creator. That really keeps me balanced. I keep striving to free myself, if not in this world, maybe in the next. I'm trying to be a better person and to make a positive impact.

I was a confused individual when I came to jail. My perception of life was very narrow, very naive. I couldn't read or write. Now I have my GED; I have college credits. I know how to read and write Spanish and Arabic. I've got a barber's license. I'm writing a book. I've been affiliated with a lot of organizations—Lifers', Latino, the Jaycees. I've been busy since I've been in prison here. I've been trying to get in touch with the good qualities of life, doing good for others.

I wouldn't have been able to accomplish these things if it weren't that God has accepted my repentance. I made a mistake and God has forgiven me. Now I'm trying to prove that I'm worthy of that forgiveness in my daily life.

I look at the electric chair as more humane than being tortured like this. Yet I don't believe in the death penalty, because most people who make mistakes are caught in a vicious cycle. They are victims themselves. So everybody is being victimized. It's got to stop somewhere. Violence doesn't solve anything.

People who show no remorse should be in jail the rest of their lives. Some did real vicious crimes. But for most people doing life, the crime was an accident. It was out of passion. It was out of drugs. It wasn't premeditated. They should be given another opportunity to prove themselves. Those who earn it should go back into society and share their experiences so that other people don't make the same mistakes.

We talk about God being forgiving. And we talk about being people who follow God. We expect God to forgive us, but we can't forgive our fellow human being. That's really a shame.

I'm 41 years old, and, as I look back, I see that life is a real valuable commodity. So even though I'm in the penitentiary, I'm thankful every day that I'm blessed to be alive.

BENJAMIN VELASQUEZ

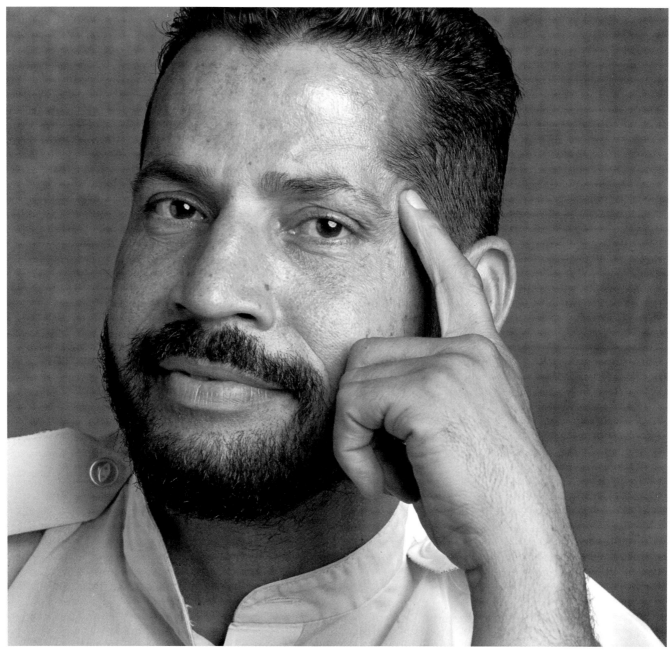

BENJAMIN VELASQUEZ

"I realize I made a mistake, and I repented many times. I asked God to forgive me. I made a negative impact. Now I hope I'm blessed with the opportunity to make a positive impact in the world."

The hardest thing about a life sentence is being away from my family. My daughter was only two and a half years old when I came to prison. She's now 23. She's grown, and I missed her entire childhood. And my relatives are getting older.

The other thing that's been hard is that I now know who I am, and I know that I've become a responsible person. I'm a very talented person. I don't mind saying that I feel I'm being stifled in here. I'm hung in the balance between trying to overcome the limitations of the prison environment, and trying to adapt to them.

I've been here the longest of any woman in this prison. When I came here originally, I had the death penalty. Three days after I received it, the U.S. Supreme Court abolished the death penalty in Furman v. Georgia [in 1974]. It took approximately a year for the courts to take me back and resentence me. In the meantime, I went through a roller-coaster ride because the district attorneys used mine as a test case to keep the death penalty. I was in and out of court, and it was a ball of confusion. I was a confused young lady to begin with, without the stress of facing that trauma, and basically alone.

The process of finding out who I am was gradual. I spent a lot of time at first in solitary confinement, and I got into reading my Bible. I began asking, "How did I end up here?" I had a lot of emotional dirt from my childhood and young adult life to wash off in order to really get down to ask, "Who am I?" It took me a few years to realize that I don't have to let people lead me around, that I'm capable of making rational decisions.

People think that rehabilitation means the system has succeeded in their program to rehabilitate you. Their programs can't rehabilitate; you have to rehabilitate yourself. There are women who have been here almost as long as I have who are no further ahead than the day they stepped in. There are others that have been a true success story. These women chose to grow and to rehabilitate themselves, to make their lives not only suitable for the outside, but very suitable for living in prison.

About three years ago I became a welder in the maintenance department. I love this kind of work, and I spend most of my summers outside. And I spend almost all of my free time painting. This past year, since I've been out of college, I've been bombarded with commissions for art work, and I love it. I wish I would have pursued this in high school. Even as a child, I was fascinated with art. And I was a nature lover. I grew up on a farm, and if they said, "Dobe, you can leave here tomorrow," that's what I would be looking for—a place in the country, a farm perhaps, where I could get back to doing the things that I should have been doing 22 years ago.

MARILYN DOBROLENSKI

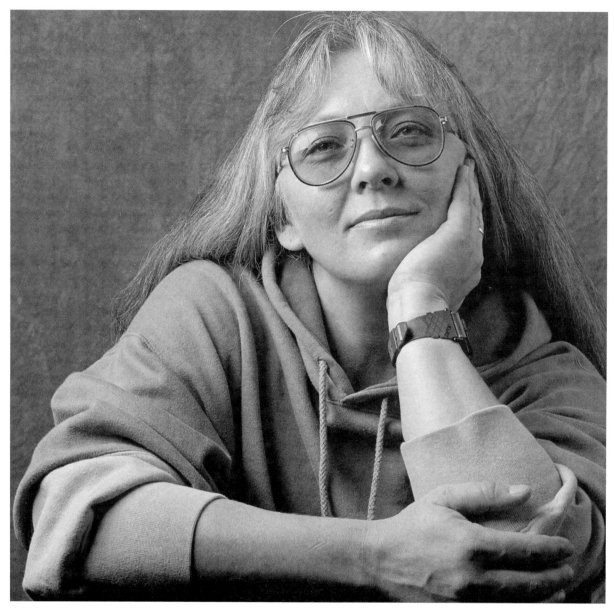

MARILYN DOBROLENSKI

"It's like fishing. The river looks calm and you forget to drop anchor. You don't realize that your boat has started to drift into rapids. Then you get stuck in a whirlpool. You get sucked under and then come back to the surface. Other people go by and they miss it, but you're stuck in that whirlpool.

"Just about the time you think you'll be able to break free of this, the water sucks you right back down."

It's ironic. Old debts were forgiven in World War II. You had a devastating war that the whole world was involved in. But after awhile they decided, "You guys can't pay your bills so we're going to wipe the slate clean." These were enemies, but somehow they found it possible to forgive. Yet the people in this society don't want to extend that same courtesy to its own who have made a bad decision.

HUGH WILLIAMS

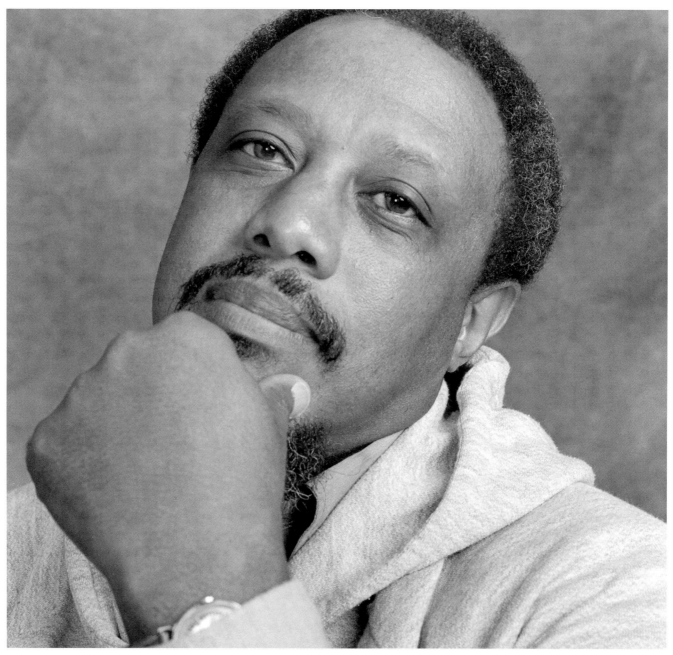

HUGH WILLIAMS

"When a person lies down to sleep, it means more to a lifer to have accomplished something during that day. I tell you, everything that we do generally has a purpose. We have to fill our days with responsibility. You can't just lay to waste."

A life sentence is just plain loneliness. It's a place where you doubt so many people, you end up doubting yourself. I realize the enemy isn't the physical dangers; it is stopping being of worth to anybody. I question my worth all the time. If if I am of no value in life, I am in fact dead. So you find something of value, of meaning, and you commit to it.

For the first couple of years, lifers believe they're going to get out through the courts. They go through a sleeping phase; they'll sleep 18 hours a day, like Rip van Winkle. They can't deal with the environment, so they sleep and dream. I went through that. Then you get tired of sleeping and go through a TV phase, or games of chess, or something to occupy yourself. You're always saying to yourself, "I'm going to get out; I'm not really a lifer." You're going through denial.

Only after the fifth or sixth year does a lifer really begin to think, "I'm doing life; I'd better start taking care of business." But it doesn't always work out that you go to school and do something with your life. Drugs and homosexuality are also ways to adjust to your environment.

Very seldom does a lifer think about his crime. It's not asked of him. As a matter of fact, he'll put things in front of him to purposely occupy himself so he won't think about it.

There's no place to talk about guilt in prison. If I went up to my counselor and said, "I want to talk about the guilt feelings I have," he'd say, "Why are you telling me? Go call your mother or see the priest. You're talking to the wrong man." There is no mechanism for it because it's not considered important. Do your time. If they review you for possible release through commutation, then it's important. Other than that, we don't care if you're sorry. It's irrelevant.

That's where the system fails because it forces a person to go back farther and farther into his mind until the crime doesn't exist. And they just see their end of the suffering and don't see the other good people who suffer.

Moses was gone for 40 days on a mountain, and I guess the solitude was good. But he didn't stay up there for 40 years. It would have been too much.

VICTOR HASSINE

Victor Hassine is author of the recent book, Life Without Parole: Living in Prison Today.

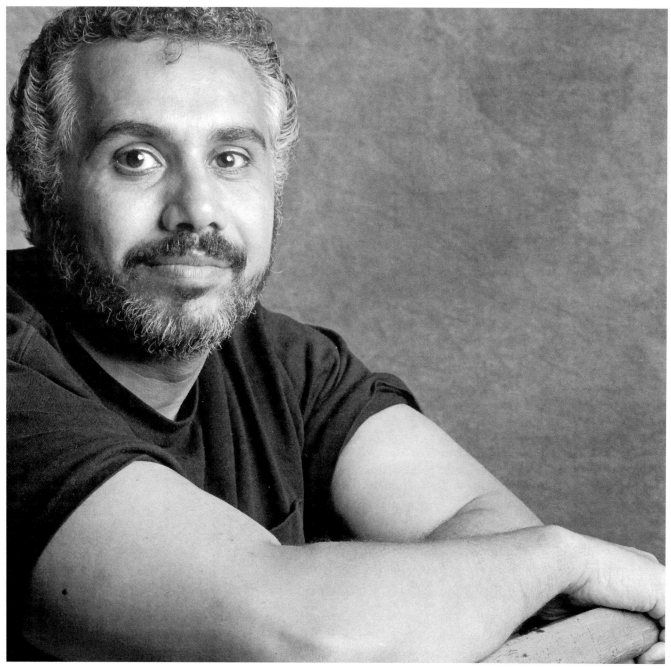

VICTOR HASSINE

"A life sentence is a man with an itch on his nose. He's carrying a big bundle of books and his nose is itching, but he can't get to it. It's torturing him."

More than 20 years ago, because of my participation in a robbery in which someone was unintentionally killed, I was convicted of second-degree murder. Now I am one of nearly three thousand inmates in Pennsylvania serving a sentence of life in prison without possibility of parole.

In this state, a life sentence means *life*. The only hope of release for lifers in Pennsylvania is commutation by the governor. Given the arbitrary and political nature of that process, shaped as it is by shortsighted, "get tough" policies and public fear and anger over crime, the average lifer has no more hope of freedom than the death-row prisoner has of having his sentence overturned.

It's difficult to explain to someone outside these walls what a life sentence is like. Imagine being without work or employed at less than a subsistence wage with no opportunity for advancement or other options. Or living in a labor camp away from family and loved ones. Or being stationed in a dangerous combat zone while your children grow up without you, fearing they will never see you come home alive. Or being marooned on a desert island where your only hope is the unlikely chance that you will be spotted by a passing ship. Each of these gives a small sense of the kind of anguish involved in being imprisoned for life.

Of course, at a time when executions are seen as an acceptable redress for the crime of murder, some may feel the life sentence itself is a mercy. I have spoken with many activists who, in their opposition to the horror of the death penalty, see the sentence of life without parole as an alternative to be embraced. Considering this, I am reminded of a historical situation that offers some parallels.

In the 1830s, when slavery was still a thriving institution in this country, a group of northern religious leaders became concerned that there were slaves who, because of "habitual insubordination" or a "disrespectful attitude," were being executed by their masters. These reformers, understandably horrified, opposed the killings—but not the system of slavery.

Looking back, we share the outrage of these reformers and support their resistance to these executions. But from the clearer vantage point of the present day, we can see that it was not just the killing, but the whole institution of slavery which needed to be overturned.

Over the past 20 years, I have studied the criminal-justice system from the inside out, and I believe it is, in many ways, every bit as flawed an institution as was slavery. From the promulgation of unjust laws; through flawed police investigations, arrests, interrogations, and deal-making; through unfair judicial procedures and conditions of incarcerations, the whole criminal-justice paradigm is awry and in need of fundamental reform. The sentence of life without parole is among the most unjust, most immoral, least effective, cruelest, and most barbaric of our punishments. It is nothing short of execution by installment, the death penalty in slow motion.

I applaud those who, because of their deep concern for life, oppose the death penalty. But we as a society must not replace the horror of legalized execution with the icy hopelessness of

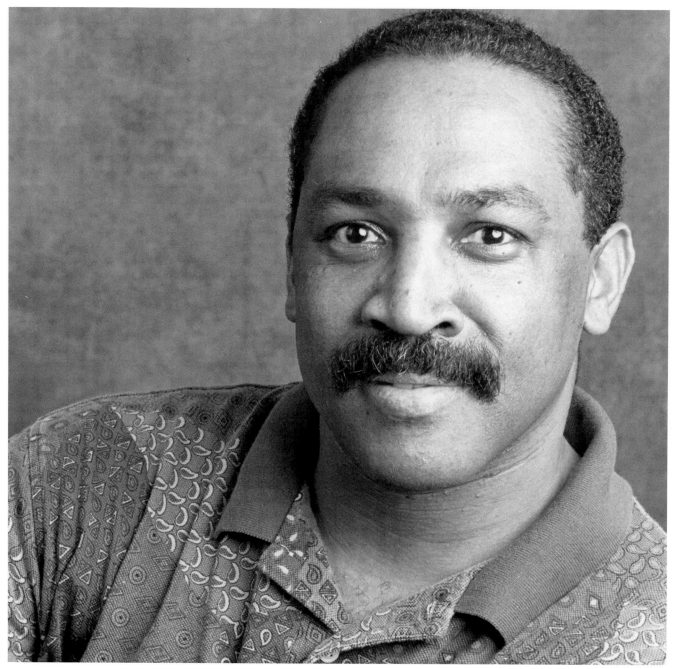

TYRONE WERTS

"Every time I watch the space shuttle go up, I think of taking a walk in space and being left up there, waiting for time to end. That's what a life sentence is like."

life in prison without hope of parole.

Those of us who have been locked away for life are not the monsters we are sometimes made out to be. Most of us are folk who, in a fleeting moment, whether through blind rage, uncontrollable passion, accident, or fear, performed an irrevocable act that we are genuinely sorry for.

The majority of us are sensitive to the needs of the victims of crime. Many of us have come from the inner cities where our own families have been victimized by crime. We can imagine the pain, the anger, the anguish that victims feel, and we are sorry and deeply regretful for our actions. We have been living with our grief, sorry, and punishment—and will carry the weight of our remorse for the rest of our lives.

Many of us have contemplated life and death over several decades. I assure you, no one knows more about the preciousness of life than those of us who have taken it and are truly repentant.

The monumental waste of human and financial resources which takes place in our prisons is something we can no longer afford. And we must not fool ourselves into thinking we can reform the system simply by constructing more cells, hiring more guards, training better counselors, or improving food and health services.

A much more fundamental rethinking of our criminal-justice system is needed, not just for men and women like myself who find themselves caught up in it, but for society as a whole.

We must find new ways to respond to crime, ways which right what has been disturbed and mend the awful damage crime causes in our communities. All of our lives depend on it.

TYRONE WERTS

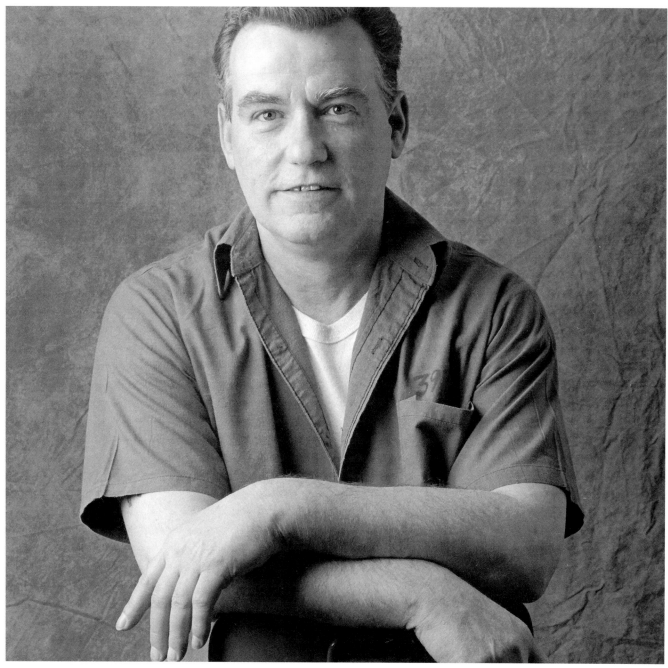

JOHN JAY MCINTYRE

"The hardest thing is not knowing when. A date. If you had a date, then you could look for something."

A life sentence is so very easily gotten and so hard to get off you. Once you've been through the courts, it doesn't matter to anyone except you and your loved ones that you did or didn't do the crime. Whether you're guilty or not, you're doing the time for it. So you have to gear yourself toward the system and do what you have to do.

I've been here 21 years. I missed my womanhood. I missed having a child. I missed living with someone. I missed all the things that make you a woman in society. A lot of me died here, and I had to go out and find a way to stay alive. Hope leaves you, but you still gotta get up the next day and breathe and smile.

LETITIA SMALLWOOD

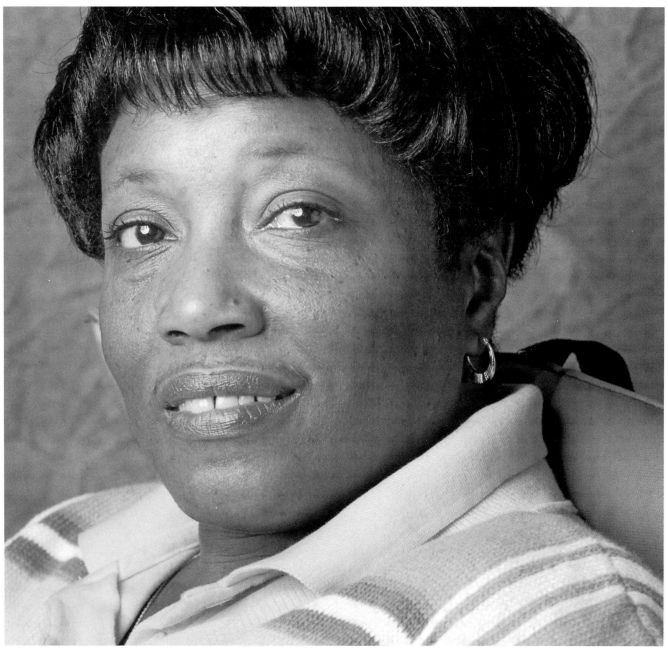

LETITIA SMALLWOOD

"There are many days that I wish I was able to say that I killed someone. That would help explain why everything that has happened to me has happened. It teaches you that there are no answers to some things in life."

A man with a life sentence is a man who is isolated from human community. He has been sentenced to death. The only difference between him and the man on death row is that that man knows the day he is scheduled to die. The lifer lives each day without knowing. But any day can be the end of his life.

Like all living beings, a lifer learns to adapt and to survive. But some of us go a little farther. We contemplate our lives and the way we live them. We contemplate such things as God, life, death, heaven, hell. What it means to be human on this planet. If you're fortunate, you will find something to believe in other than yourself.

Faith is now a part of my everyday development. It wasn't until I really began to believe internally rather than just lip-professing that any changes actually came into my life. One need only look at my prison jacket to tell that my prior actions weren't the actions of a man of faith. Actually, I was trying to annihilate myself right from the beginning.

I was a criminal in mind and in deed. The reason I could be accused and convicted of a crime that I didn't commit was because I had a criminal nature. It wasn't beyond me to do the thing I was accused of. Everyone knew I had those capabilities. But, in fact, I am serving a sentence for someone else.

If you do something really harmful and it has a profound effect on another life, there is no real payment of that until that person can forgive you for your offense. Or until you can face them and let them know you are repentant. Any time that you serve in consequence of your action is a penalty that you really haven't paid until you are truly repentant for the act.

I know I've touched a lot of people to whom I've done harmful things. I don't even know where they all are. I would like them to know that for anything harmful Robert Hagood has ever done to you, I'm sorry. I beg you to forgive me, just as I beg my Lord to forgive me.

ROBERT HAGOOD

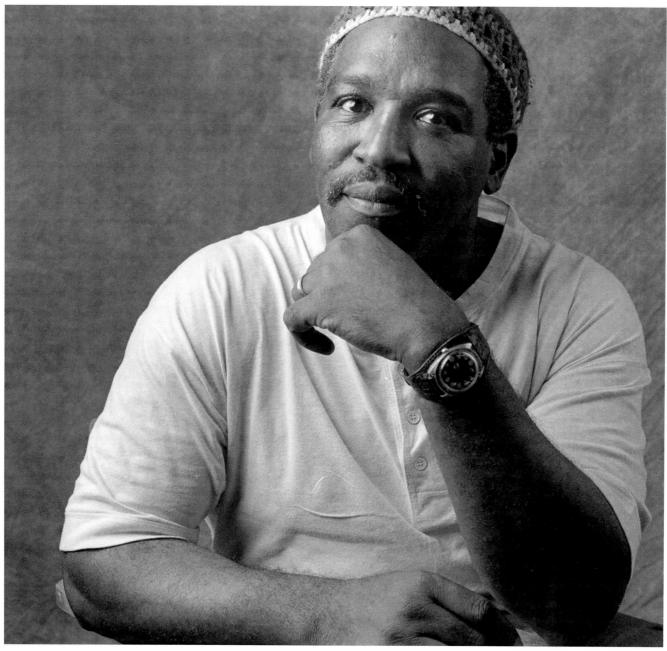

ROBERT HAGOOD

"If God gave me one wish, it would be that I would be accepted on the basis of my sincerity of repentance. And that I would have the wisdom to live my life every day without ever doing anything harmful to another living thing."

The biggest part of my bit is veterans—I'm head of the veterans right now. No less than 25 percent of the lifers here are Vietnam veterans, combat veterans. Many are suffering from PTSD—post-traumatic stress disorder.

A lifer has to keep up his stamina, keep up his awareness and mental capacity. And try to hold onto his family, if he has one. That's a lot of pressure, a continuous struggle. You never know if you're going to make it.

What's most frightening about a life sentence is knowing I've acquired the capabilities and the knowledge to be somebody, to be a productive citizen, to be able to help others not get caught up in this situation—and not being able to really get out and help. I see our communities dying. I see our families breaking up. And I know that I have something to give.

This is my community right now. I'm living here. I have to try to make this a better place to live. I have to try to make this a better place for you to come into. And the only way I can do that is by being real, honest, truthful—not only with you but with myself.

In Vietnam, you asked, "Can anything be worse than living in a pup tent, being shot at, not seeing your enemy, killing women and children?" But there you had hope. You did have a sense of power; you had a fighting chance. Here it's different. You're completely powerless.

For the first three or four months in Vietnam, I believed that I would come home. For the rest of my tour, I didn't care. There you built a wall to protect yourself, a wall of anger, and the wall didn't let you care about anything. You didn't let people get close to you.

Here the wall that you build doesn't take away the caring. The anger in here is different. I'm angry that I'm in jail, away from my family. I hate this place with a passion, and that has made me able to survive and to push forward. Not being able to go to a refrigerator, not being able to see my woman but a couple of hours a month, not being able to talk to my grandchildren, people telling me when to go to bed, what to watch on television, when I can eat, what I can wear— I hate that, although I know it's my fault. But I've channeled the anger. Now I want to do what's right, to be a productive citizen.

We are willing to take it upon ourselves to try to better the community so that others won't follow in our footsteps. I would like society to take a good look at human beings and know that changes can be made, that changes are made by a lot of human beings who are doing life. There are a lot of good people sitting in these penitentiaries who are needed outside.

COMMER GLASS

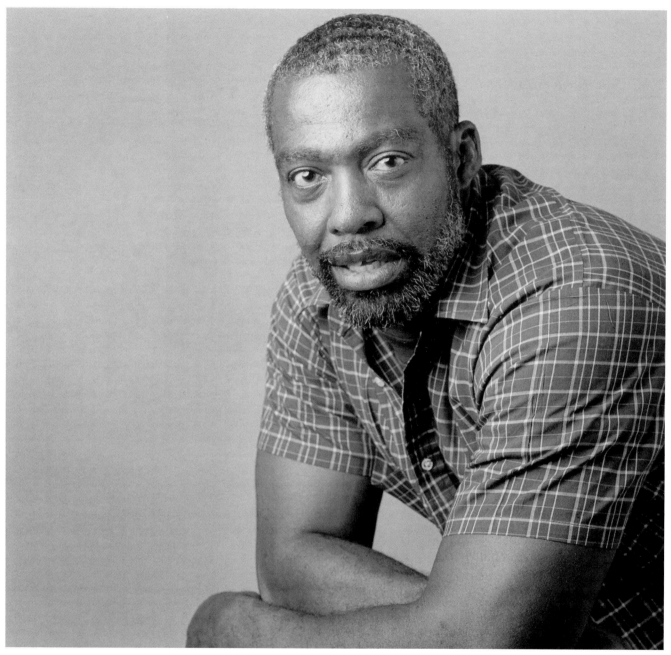

COMMER GLASS

"It's like going deep-sea diving. Going all the way down into the depths and losing your oxygen. You're struggling to get to the top. You don't know if you're going to make it, but you never stop struggling."

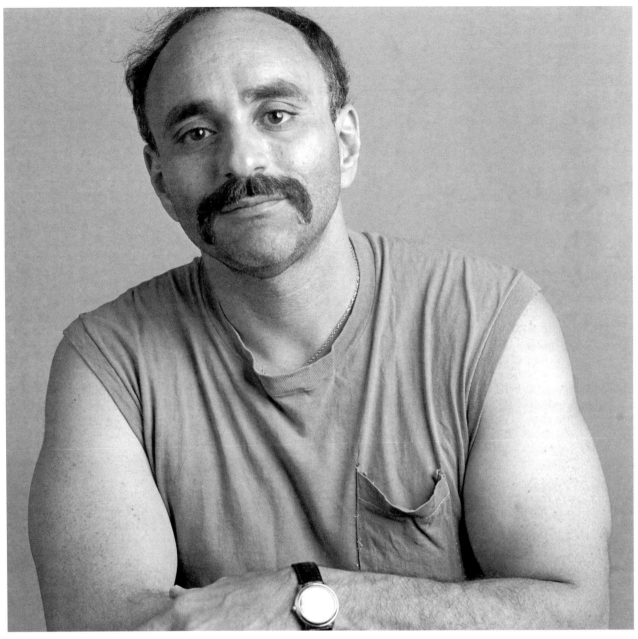

ROBERT CAPORELLO

"It's not only what I did to my own life. What about my victim's life? He was 21 years old, too. I pray for him every week. What could he have accomplished in this world? What would I have gone on to be? What about the children that we would have had? What could we have given to this world?"

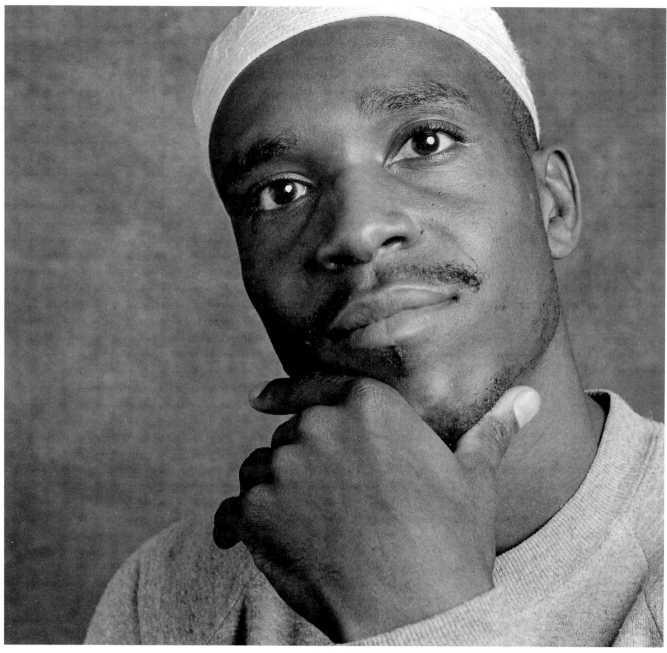

DERRICK MUCHISON

"You sit on your bed and you say, 'This is a dream. Is this a dream? Why can't I wake up?' But the only way you wake up is through death."

Last time I heard from my daughter was in 1970. She was a little girl at the time. It's painful, but you have to let it fall where it should. It's not her fault; it's my fault. I did this to myself. No one made me do those things. So I'm not complaining. I deserve this time. I took a life, and in taking that life, I not only put a burden on my family, I put a burden on that person's family.

As far as guilt for the death, I think about that all the time. I had no business shooting that woman. I didn't even know her. I had no business taking that boy's mother away from him. So I'm not saying, I've been in jail 30 years and I deserve to come home. That's crap. I am asking for mercy. I'm not asking because I deserve it, because I don't deserve anything. I took a life, and I can't give it back. This is something that weighs on me. I never killed anybody in my life until that point. When I was in the army, I never killed anybody, and there it was more-or-less legal. It was war.

What happened that night, though, was a logical outgrowth of the way I was living. I didn't consider other people's property, other people's feelings. All I was after was what I could get for me.

Back then I was enjoying myself with drugs. I was hanging out with the musicians that were dope fiends. One of the biggest trophies I had is that I shot dope with Charlie Parker. He was the man back in those days! And I shot dope with Billie Holiday.

Now I don't think the same. I want to sit down with nieces, nephews, and grandchildren and get to know them. I want them to get to know me. I didn't give a damn who knew me then. Now I'm doing what is expected of me, and I feel good about it. My remorse will have to

be shown in the things that I do.

I've been here going on 30 years now. Man, I'm so tired of this. But I can do the time now. I can see I can do it now, because I've done it. The wonderful thing about this whole thing is that I've been able to do it without relying on drugs to hold my sanity.

I think, "I am a better person than this. I've fouled up, but life's not over with." Will I get another chance at it? That's what I want to know. And if I do, will I let anybody down? I doubt it. If I was to go out of here tomorrow and commit another crime, I would not only be hurting my family and myself, but also all the other lifers I left back here.

RALPH SHARPE

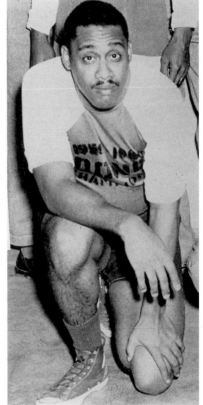

young
RALPH SHARPE

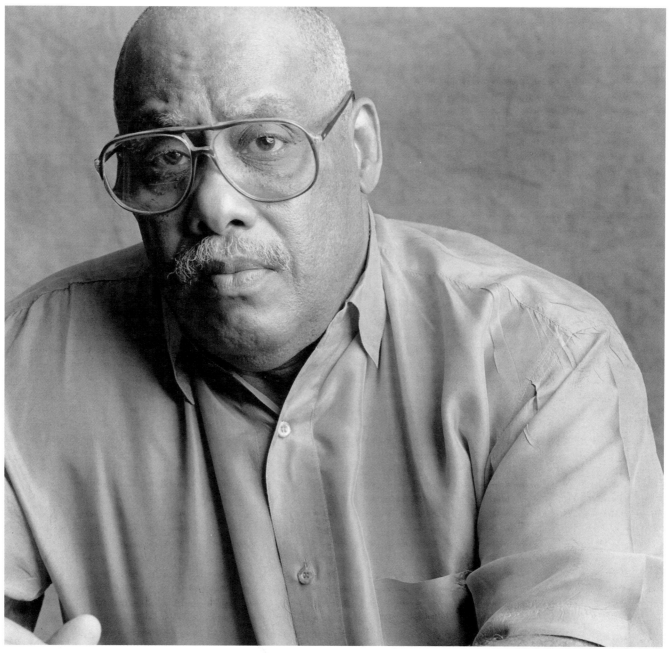

RALPH SHARPE

"The life I took, the grief and the pain I caused, is something I can never give back. On my commutation forms I don't ask for anything from the victim's family because I feel that I deserve and earned this."

A life sentence means you're incarcerated from the time you're convicted, or the time you're arrested, until whenever the whim of the governor might feel like letting you go. It might be 20 years, 50 years; it might be forever. Might never let you out.

I would compare a life sentence to a lottery because there's no rhyme or reason. Out of 75 recommended by the Board of Pardons, three might make commutation. Seventy-five, deserving by everybody's recommendations, but maybe one or two or three that the governor feels are politically expedient to commute. Merit doesn't mean anything. It's like you would throw 75 ping pong balls in a bag and pick out three. So at this point we really don't have a viable outlet in commutation. It's a joke.

I have to keep going because I have invested a lot of my life in here. I would like to do something with my life. I don't have that many alternatives. I could hang myself. I could run. Those are the negative things. But if I do either, it's like I'm taking the past 29 years in here and throwing them into the trash bucket. So my alternative is to continue and hope that at some point I'll get the benefit of the recommendation for commutation.

The only hope is that one day my number will be in that lottery and they'll let me out. Maybe I'll have a couple of years of life left. That's my goal, and I don't intend to hang up or do something negative to justify everything they've done to me. Then they would say, "This man doesn't deserve anything anyway."

Writing has been important to keep me going. I started studying the law; then I just started writing about the prison system and various areas of the justice system. That has been my outlet for my inner hostilities, my anger. A positive way to let it out. Plus I do it with the hope that maybe one day the message will get to enough people that the movement will grow and people will see that something's wrong here.

Even if you're in a hole, life just doesn't stand still. You don't just stand still. You're either going to become better or you're going to become worse. I've never seen nobody stay the same.

DAVID BROWN

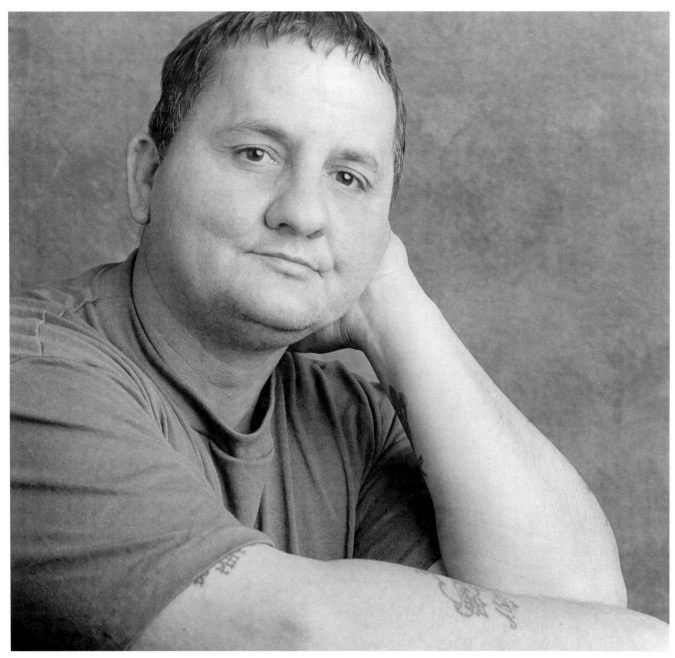

DAVID BROWN

"Recognizing what happened to the victim and what happened to his family and what happened to my family, I began to realize that there are more people in life than me. I learned that my actions affect more people, not only myself."

I've been blessed to be able to set up programs that have benefitted other residents in the prison system. I'm a former boxer, and I use boxing as a vehicle for life skills for the younger fellows who come in. I see it as a source to enhance their self-esteem, to help them get educated, get their GEDs, get in programs that can help them once they leave this environment. So I never saw my being in prison as the end of my existence. And it has helped other people see me as a person rather than a label.

Being in such a cubbyhole has probably quickened the pace of my maturity. And it has sensitized me to my fellow human beings. I have learned about human nature. This is a perfect place to learn human nature.

Some people are devastated that they can't see any light at the end of the tunnel. A life sentence can become a living hell if the foremost thought in your mind is that there is no hope. There is a tremendous amount of suffering that goes on here.

If you give a person a life sentence with some hope, it can be endured. Some people, I do believe, need supervision. Some may need it a little longer. But for the rest of their natural lives? I have great reservations about that. I do think a person ought to be given hope.

We are all brothers. We do have faults. God doesn't ask us to be perfect. He asks us to seek a degree of perfection in this life. That's what I strive for.

OMAR ASKIA ALI

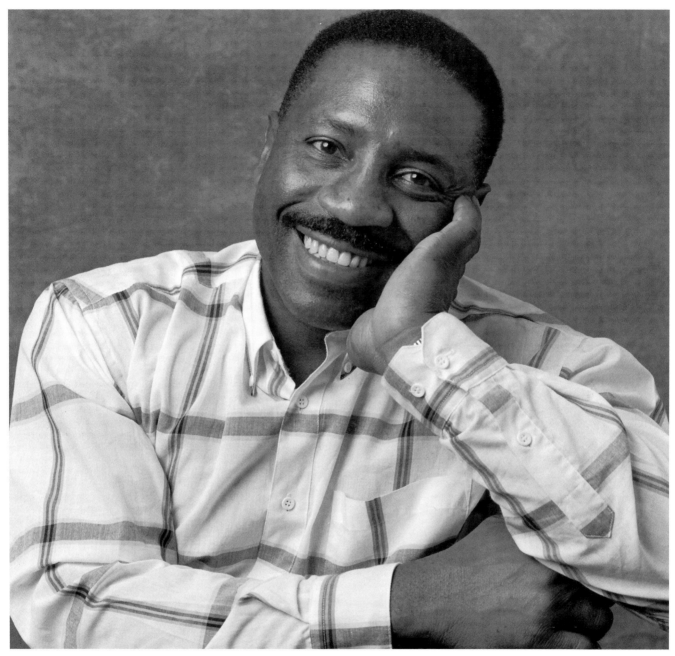

OMAR ASKIA ALI

"We live in a society where the Creator is often forgiving and most merciful. If we believe in our religious doctrine, when it comes to situations like this, I believe it should be employed."

The first three years of my sentence I spent in solitary confinement on death row. It's like what I perceive blindness to be: you kind of lose your balance; there's nothing that steadies you. When you lose contact with other people, it leaves you in a kind of darkness, a limbo. It's like being in a dark room with a blindfold on. There's no visual light, but, after a time, your imagination creates light for you. We all need an outlet from frustration and loneliness, so we create our own sense of light through our hopes and dreams.

I don't believe women are released as soon as their male counterparts or even, in some instances, their male codefendants. There have only been a few clemencies for women in Pennsylvania in the past 15 or so years.

Partly that's because women don't have the type of support systems that men have. Women seem to be more loyal to their spouses. If your husband or brother goes to jail, you try to have some type of support system for them, but it doesn't work that way for women in jail. Also, the majority of women lifers either have committed crimes with their spouses or weren't married and didn't have these bonds in the first place. So if you put women in a remote place like Muncy when the majority of them are from Pittsburgh and Philadelphia, they lose their link to their communities. This is especially true since the majority of us come from inner cities, and with the restructuring of inner cities, you have whole communities that no longer exist.

The parole board is very male-oriented, and I believe that men have a set idea about what women should be and do. When women are outside the norms that men in power have cre-

ated, then it's like a double whammy because you disappointed them. They can't even imagine a situation that would cause a woman to participate in violence or in criminal activity. The violence of men, on the other hand, is accepted. To be a man, you fight back; you're assertive. It's understandable that a man would steal for his family, would push and shove when he's being attacked. But it's not excusable for a woman in that same situation. I think this attitude prevents a lot of women from being released.

No, I'm not happy. I believe that I have to make the best of the situation that I'm in, and, in doing so, I've come to a little peace with myself. I at least understand my situation, and my skills for coping are a lot better. Some things make me satisfied with myself and my situation and give me a sense of accomplishment.

About 15 years ago, I got involved with the education program. I eventually received my GED and associates degree and was able to be involved in the Penn State program. That afforded me the opportunity to become one of the first lifers in Pennsylvania to be an employee of Pennsylvania State University. My job title is Student Services Liaison. Initially my job was to design an associates degree program that would be flexible enough to include the majority of inmates at Muncy. Now I am a Student Services Liaison for the inmate population. I tutor when necessary, I find funding, I do paperwork for grants, I'm the elected chairperson of the task force that oversees the secondary education process here. I get a great deal of satisfaction from my job.

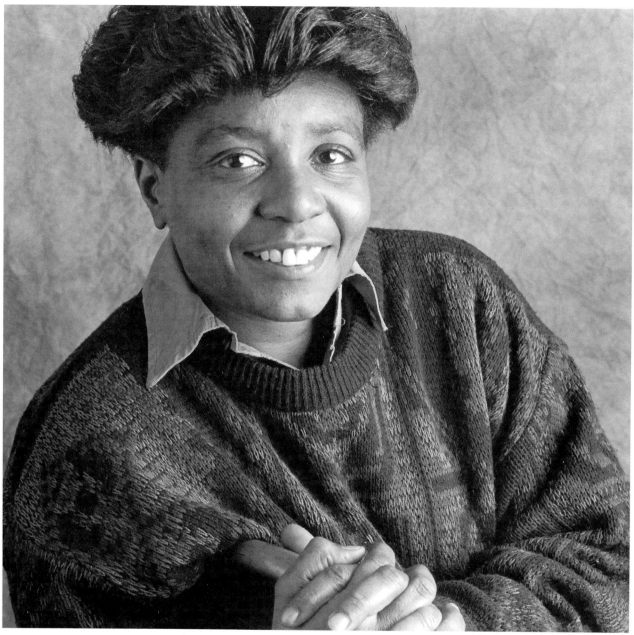

SHARON WIGGINS

"I understand that there has to be a punishment for people who commit such crimes. I'm not sure whether I can be objective about what that punishment should be. I guess it should be left to the community to decide."

For me, then, the key was education. I found the more I learned, the more I learned about myself. Doing that, I found I had a gift for educating others. So I use that tool to enhance not only my character, but my fellow inmates' situations.

When I came to Muncy I was 17. When I look back, it doesn't seem like I was physically involved in the growth of Sharon Wiggins. It's more like I'm looking back on a child, watching her grow and develop. I have a hard time believing I'm the same person who came to prison 27 years ago. But I realize that if it were not for those experiences, I would not be the person I am today. So I hold on to that part of my past in order to recognize this part of me now.

I had to grow up in prison. There was not a lot of guidance but a great amount of discipline. The difference is that you get the discipline without the explanation. So it took about 10 years to get in touch with myself and my surroundings, with the painful feelings that I had about being incarcerated, with the realization that the mistake I made is irreversible. It is not like you can say you are sorry and it will go away. So you have to come to some resolve about how you want to deal with that. It's hard because there are no rules or guidelines. You have to experiment and find ways that will not really compensate, but will atone for the past.

What got me here was that on December the 2nd, 1968, along with two male accomplices, I was involved in a bank robbery. During the course of the robbery, a patron and I struggled, and during the struggle, I shot him twice. I was originally given the death penalty for my participation in that crime. About three and a half years later, I was retried and sentenced to life.

I was raised by my grandparents and have a lot of fond memories of them. But in 1965, my grandparents passed away within months of each other. They were my real family structure, so after their deaths, I found myself virtually in the streets. I was 13 or 14, living in an adult world with the disadvantage of being an adolescent. I had to make adult decisions with an immature mind. So I basically made all the wrong decisions. I was out of control as a teenager.

My actions at that time have affected the last 27 years. I think about it with a lot of regret and sorrow, not only for the tragedy that I created for myself, but mainly for the tragedy I created for my victim and his family. When you understand the finality of taking someone else's life, and you understand that there is nothing you can do to make the situation better, it's painful, the responsibility of that, of my actions. The responsibility that I feel for that sometimes is overwhelming.

If I could meet my victim's family, I guess I would want them to understand how much I truly regret my actions. It's just difficult when you think about facing people whom you've hurt so badly, but I guess I'd like them to know and understand that I'm deeply sorry for my actions. I would just hope that by the way I spend the rest of my life, whether it's in prison or not, they could in some way see that I do understand what

I did and that I'm trying to change other people's lives. I hope in some way it makes up for my irresponsibility before.

Over the years I've had to examine my life, specifically the things that brought me to prison. You do the best you can with what you have. You try to create positive situations, not only for yourself, but for others.

Most of my adult experiences have been in prison. In prison, you see all levels of experience, of pain and misfortune. We all want to be loved and nurtured and responded to in a positive way. Those are the things that link all of us together as human beings. I have a duty to respect and recognize not only my value system, but the value system of others.

I do believe good can come of a life in prison. Once you've had a chance to evaluate the things that brought you to prison and have come to terms with them, you can get something positive from this experience.

There are rehabilitation programs that do work for people here. The problem is that there is not enough space in most of them to give enough people the opportunity to participate.

I don't like to use the word "rehabilitation," though. A person matures into a different kind of individual. I believe that is the norm when people are in bad situations and have to face themselves and find a way to incorporate their emotions into acceptable behavior.

I look at the case of the three teenagers accused of murder in Florida recently. I hope that nobody gives up on them. To lock them away forever just validates what is already in their minds—that things are hopeless. If somebody encourages them and allows them to see that some people do care about them, that would be the best punishment. I know there are individuals here who came to prison at a very young age and who matured into different kinds of individuals.

SHARON WIGGINS

Sharon was recently laid off because of funding cutbacks.

I was a substance abuser. I'm not excusing myself for my actions. It is a fact, just as it's a fact that I was a lieutenant in the army and resigned from that. Just as it's a fact that I was a college graduate and that I got a master's degree while I was in prison. All of these things are good things to know about Kenneth Tervalon. He happens to be a fellow that God has gifted with a certain degree of intelligence.

Through the grace of God, I've been fortunate enough to be in my right mind long enough to use those talents for good things. The other part is that at one point in my life, for a brief period of time, I did something that caused a man's life to be taken. I have to pay the penalty, but, given what I have done in prison, I also feel that there should be an opportunity to be reviewed.

Initially, the worst thing about my sentence was my denial that I was involved. All of the professionals advise you to deny your involvement. And I did. And once you begin denial, you set yourself on a bad road. You build a lie.

Eventually I came to grips with the fact that I had done a terrible thing and was able to tell anyone who asked what I had done. So I was able to live at peace with myself.

I think God changed me. God tapped me on the shoulder. I think a couple of times He hit me up aside the head. For a period of time He was touching me and I wasn't listening. And there a came a point when I really wanted to listen.

KENNETH TERVALON

Soon after this interview, Kenneth Tervalon became one of the very few whose sentences are commuted by the governor. He is now on parole.

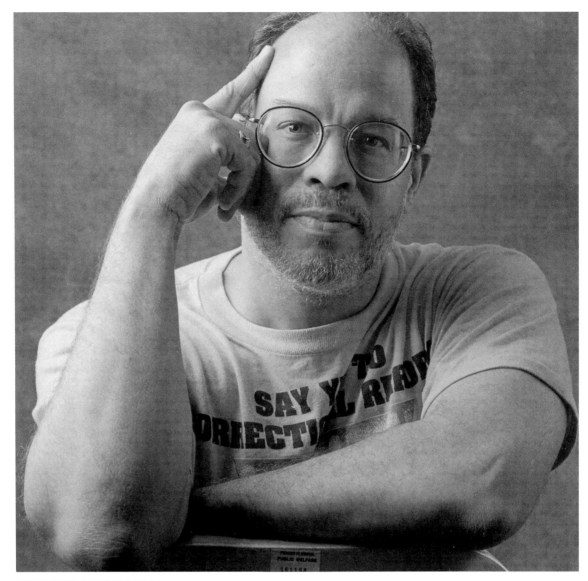

KENNETH TERVALON

"Those parables about the lost sheep, the lost coin, the one about the son who squandered his inheritance, are very much what we're talking about with lifers. Many of us are lost sheep. Many of us are lost coins. And many of us are that son who just went away and squandered everything on lavish living. We'd like to go back and work in the garden as a laborer. Very often our fathers would have us back. But our brothers don't want us back. We're asking our brothers to forgive us and to take us back."

WHAT DOES ALL THIS MEAN?

Life is a constant struggle to blend the disparate fragments of our lives. This project represents one of those rare intersections for me, a convergence of two intense personal involvements: criminal justice and photography.

In one part of my life, I am director of a national criminal-justice office which addresses a variety of victim and offender issues. In 1978, I also helped develop the Victim Offender Reconciliation Program (VORP) which now operates in many communities in North America and Europe.* I have been involved in the movement to promote a "restorative" understanding of justice, as well.

The opportunity to work with victims, offenders, and communities struggling with justice issues has convinced me that, as a society, we are so preoccupied with punishment that we often miss the point of justice. We talk a lot about criminals and what punishment they deserve. To a considerably lesser extent, we talk about victims. Because the American legal system positions offenses as crimes against the *state*, victims and perpetrators take on the quality of symbols caught in an abstract drama. The real meaning of crime and the real "players" are often obscured.

Victims complain of being twice victimized, first by the offender; then by an unresponsive justice system which ignores their interests and needs. This neglect of victims is not easily rectified by adding a few programs. It is not the result of uncaring professionals nor of minor defects in the delivery of justice. Rather, victims are neglected because victims are not part of our society's actual definition of crime.

Our legal system defines crime by the laws that are broken more than by the harm actually done to individuals. It identifies the government as the victim, not the individual person hurt. In many cases, victims are only called upon—or even informed about their cases—if they are needed as witnesses.

Justice is essentially a matter of establishing blame; then administering pain to the offender who is responsible. Stated simplistically, justice can be summarized in three questions: What laws were broken? Who done it? What punishment do they deserve?

Legally, then, crime is an unlawful act by an offender against the state, making the offender and the state the two key components in justice. Since victims are not part of that equation, it is no surprise that their needs and desires are rarely considered.

Offenders are punished more often than is usually assumed; the United States has the highest incarceration rate in the developed world. But while they may experience the pain of punishment, offenders are not held genuinely accountable.

Real accountability would mean understanding the harm they have done and to whom. They would then be encouraged to take responsibility, to the extent possible, to repair this harm. Instead, they are put through a complicated process that encourages them to look out for themselves. Because the state is established as the offended party, persons who commit crimes have few reminders about those who actually suffered as a result of their actions. They are given few opportunities and little encourage-

ment to address their sense of guilt and responsibility.

Consequently, victims, offenders, and the public all tend to view the whole process in abstractions and stereotypes. The actual people involved—victims and offenders—are ignored. So, too, are their experiences, their needs, and their roles.

I believe that we ought to recognize crime in the way it is experienced: as a violation of people by people. Violations create obligations, especially the obligation to make things right. Both victims and offenders have roles to play in this process. The central questions of justice ought to be: Who was hurt? What are their needs? Whose obligations are they?

We need to develop practical programs that lead to restoration for both victims and criminals. At minimum, we must start by "demystifying" crime. I have attempted to do that here by allowing us to meet real people.

My parallel theme in this project is my interest in photography. Much of my academic training encouraged me to develop my rational self at the expense of my emotional and intuitive selves. Photography has been an important corrective, a way to cultivate other essential ways of knowing.

Because visuals connect to our emotions, they can address and communicate when words alone are inadequate. Think of some memory— of a childhood experience, of a loving encounter, of something that frightened you. Chances are you see an image in your mind. Chances are, in fact, that you see a *still* image, not a moving image. We seem to remember in mental photographs.

Images are not only the building blocks of memory, they also hold emotion. Explained painter/photographer Ben Shahn, ". . . emotions exist in image form. And I believe that emotion cannot exist free of image."

If images are this basic—the carriers of memory and feeling—photographs have the possibility of being powerful material! If we are intent on exploring and communicating about the emotional issues that surround crime, we cannot neglect this dimension.

This is not to say, however, that images by themselves often change minds. To be sure, a few images have made a dramatic impact. Most people, even those too young to remember the Vietnam War, remember Eddie Adams' photo of the South Vietnamese chief of police shooting a Viet Cong suspect. Most also know Nick Ut's image of a naked nine-year-old running down a road after being burned by napalm. These two images are often credited with helping swing public opinion against the war. But for individual images to have such an impact is rare. For this to happen, they must be preceded by considerable background work. Such photographs strike a responsive chord only because the environment is right.

Perhaps changes in public opinion can be compared to an avalanche. Avalanches are not caused simply by a loud noise or other single event. Instead, a series of almost indiscernible processes set the stage. A single event such as a noise may serve as an immediate cause, but preceding events create the underlying conditions.

Most photography, and most of our words and actions as well, belong to this preparatory stage where little immediate impact is apparent. Yet this background work is essential. So photographs, visuals, are an essential element for investigating issues, but they have their impact as part of a larger effort.

Photographs are often too ambiguous to stand meaningfully alone. Rarely do they convey enough information in themselves. Who is this person being portrayed? What is going on in the photograph? As lifer Donald Montgomery says, "You can look at this picture and you don't know if this guy is doing well or if he is doing badly." Without words to provide some setting, we often have to guess. I like to find ways to combine words and images, and this project has provided an opportunity.

I have also grown increasingly conscious of the power of language and metaphor through my involvement with offenders and victims.

A metaphor is a comparison. We compare one thing to another, but don't say we are doing it. We use metaphors every day, but most of the time without realizing it. These unconscious metaphors lead our thought toward certain directions and away from others. Usually, we are unaware of these implications.

In the area of justice, one of the metaphors that shapes our thought is the "war on crime." I find this to be a particularly pernicious metaphor. It emphasizes the "otherness" of offenders, disguising the fact that offenders are very much like us. It gives the wrong impression of crime. By objectifying an "enemy," it allows us to justify all sorts of actions against those who commit crimes. It creates the false impression that the solution lies in weapons, in "outgunning" the perpetrators, in deterrence through fear. The list of implications could go on. The point here is that metaphors tend to shape our thinking, but often without our being aware of it.

In the realm of photography, the language we use and the metaphors that guide us are profoundly disturbing. Just think of the verbs: we "shoot" a picture; we "take" a photo; we "aim" a camera. Cameras are often designed and handled like guns, and in ads they are often explicitly presented as such. The language of photography is predominately aggressive, imperialistic, acquisitive, the language of the hunt.

This is not inevitable, though, and I am interested in reconceiving photography in another way. In photography, we actually gather light which is reflected back from the subject. Photographs are reflected images which we receive. Photography can be understood, then, as a gift, something received from the subject. It is an exchange between subject and photographer. An attitude of receptivity is required; an attitude of meditation is more appropriate than that of a hunt.

Photos like these of lifers are often "taken" by researchers as grist for their study mill. I wanted this project to be more subject-oriented. I wanted these people to participate and even to feel empowered, valued, treated with respect. I did not want to just take, but also to give something back. If possible, I wanted to contribute in some small way to their own self-insight, and maybe even to their healing.

Several years ago I conducted a similar project in a New Orleans housing project. Labeled by *The New York Times* as one of the worst in the country, this housing project frequently receives negative coverage in the press. Working in the style I have outlined, we eventually had an opening of the photo exhibit inside the housing project, and also presented the residents' council with their own exhibit. Since then, the residents have said that not only did the project help others to see them in more positive ways, it helped the residents themselves have new appreciation for their community. My hope is that *Doing Life* will accomplish as much.

German photographer Albert Renger-Patzsch, who worked earlier in this century, once commented, "It [photography] seems to me better suited for doing justice to an object than for expressing artistic individuality."

"Doing justice" to the subject—what a wonderful way to conceive the photographer's mission. I wanted to "do justice" in several ways in this project.

One of the important lessons I have learned from listening to both victims and offenders is that storytelling is vitally important, and that self-insight can come through sensitive questioning and feedback by another. Self-understanding can also come from seeing one's image in photos, according to the lifers after they saw their pictures. I have hoped that these interviews and photographs will contribute to empowerment and healing.

I have struggled to understand and communicate why the injury of crime is so traumatic. I have concluded that the violation of crime is fundamentally an attack on meaning, and that justice and healing have a great deal to do with regaining meaning.

Robert Schreiter suggests in a book entitled *Reconciliation: Mission and Ministry in a Changing Social Order* that we each construct a sense of identity and safety to keep from feeling vulnerable. We place our symbols and critical events in narratives—stories—about who and what we are. These are our "truths."

Suffering—whether a result of being a victim or of being oppressed—is essentially an attack on these narratives, an erosion of meaning. To heal, we have to recover our stories, and then create new narratives that take into account the awful things that have happened. The suffering must become part of memory, part of our stories.

To recover meaning, we must be able to express our pain. For many, this means repeatedly retelling a "narrative of violence." The repetition allows us to ease the trauma and to begin to construct a new narrative. It helps us to put boundaries around the story of suffering and in so doing to become victorious over it.

This need to tell our stories and "truths" is important in the process of victim-offender reconciliation. We who are mediators listen to victims and offenders as they tell their stories to each other and to us. In a small way, I wanted to contribute to the construction—or reconstruction—of meaning and identity for those whom I photographed and interviewed here.

The search for meaning is one of the themes that often emerged in these interviews. Many lifers described their urgency to make some good

come out of the bad. (This, by the way, is a common theme among victims, too.) Many of the lifers I interviewed are involved in programs to assist others and to help young people avoid destructive situations. It is their way of making restitution and creating good from bad, a way of regaining meaning.

Other lifers expressed a need to make each day count. Several suggested that, perhaps more than for us on the outside, they have to consciously work to do something worthwhile each day. Otherwise, given their bleak futures, their lives might be without meaning.

Finding hope in an apparently hopeless situation drives many of these people. So, too, does concern for their victims, even though I did not ask about this in the interviews. Questions of guilt and forgiveness were on their minds. And I heard many stories of inner journeys—of midlife crises, stages of adjustment, struggles for identity and self-worth. Many talked about the importance of religious faith.

This is not, of course, the whole picture.

Victims, too, must be heard. We dare not minimize the atrocious events that lead to life sentences. And not all lifers are like those presented here.

Yet lifers often mature into thoughtful, responsible women and men who are remorseful for what they have done and who seek ways to contribute to society. Prison administrators frequently say that, contrary to our stereotypes, lifers as a whole are the most trustworthy and mature segment of the prison population. Lifers are involved in many organizations designed to prevent crime among young people or to otherwise contribute to society.

Not all lifers have turned their lives around. However, with careful selection and supervision, many could eventually be received into society. Many could make significant contributions to our communities.

At the very least, lifers deserve to be seen for who they are—individuals with fears and dreams, much like the rest of us.

We have been conditioned to believe that art is the supreme expression of our individual selves, that in our creativity we display our utter uniqueness. I am coming to believe that our art may be more powerful and serve us better if it were to draw us together, to bring us to greater mutual understanding.

I am committed to doing photography that speaks to the power of connectedness, that calls us into relationship—relationship with other people, with the environment, with our Creator.

I hope I have done justice to the subject.

HOWARD ZEHR

* The Victim Offender Reconciliation Program, often called VORP, is a blend of restitution and mediation that, unlike most programs, addresses both victim and offender issues. Working in conjunction with the legal system, it allows victims and offenders who wish to participate to meet each other. Meetings are mediated by trained community volunteers and are intended as a forum to allow the facts of the case to be clarified, feelings to be expressed, and restitution agreements to be worked out.

Victims find satisfaction in having an opportunity to get answers to their many questions, to tell their stories, to express their sense of outrage and loss, to put a face to the offender, to participate in a settlement. Offenders are encouraged to understand the consequences of their behavior and to take responsibility for it. They have an opportunity to make amends and, if they wish to do so, express their remorse.

INDEX OF LIFERS

Ali, Omar Askia	110	Holz, Larry	9	Schulman, Julius	16
Bainbridge, Bruce	58	Joyner, Alvin	40	Scott, Marie	72
Berger, Cyd	48	Joynes, Kimerly	14	Sharpe, Ralph	106
Boyd, Frances	74	Lee, Frankie	75	Smallwood, Letitia	98
Brown, David	108	Martin, Calvin	34	Taylor, James	18
Caporello, Robert	104	Martin, Thomas	44	Telford, Harvey	57
Cloud, Yvonne	28	McGuire, Eugene	60	Tervalon, Kenneth	116
Crawford, Raymond	70	McIntyre, John Jay	97	Thomas, Renee	43
Datesman, Craig	67	Mercado, Ricardo	20	Twiggs, Harry	22
Diggs, Charles	78	Miller, Joseph	38	Twiggs, Michael	85
Dobrolenski, Marilyn	88	Mims, Jerry	46	Velasquez, Benjamin	86
Farquharson, Lois June	7	Mines, Kevin	56	Wallace, Brian	29
Fox, Aaron	8	Montgomery, Donald	62	Weaver, Diane	76
Fultz, William	36	Moore, Irvin	10	Werts, Tyrone	94
Garnett, Trina	65	Morley, Gaye	12	Wiggins, Sharon	112
Glass, Commer	102	Muchison, Derrick	105	Williams, Hugh	90
Graber, Mark	30	Nole, John Frederick	50	Womack, Leonard	66
Hagood, Robert	100	Norris, Bruce	15	Yount, Jon	80
Hassine, Victor	92	Robinson, Sherri	32		
Heron, Betty	68	Sanger, Grover	47		

ABOUT THE PHOTOGRAPHER/WRITER

Dr. Howard Zehr is a writer and international consultant on criminal-justice issues. Since 1979, he has served as director of the Mennonite Central Committee U.S. Office on Crime and Justice. More recently, he has also joined the faculty of Eastern Mennonite University.

Zehr was instrumental in developing the first Victim Offender Reconciliation Program (VORP) in the U.S. and has helped many other communities start similar programs. He has also played a central role in the development of the "restorative justice" concept.

Zehr's publications include *Crime and the Development of Modern Society* and *Changing Lenses: A New Focus for Crime and Justice*.

He has also worked professionally as a photographer, with his work appearing in many publications and exhibits.